100 WONDERFUL
MANDALAS
COLORING BOOK
FOR RELAXATION MEDITATION BLESSING

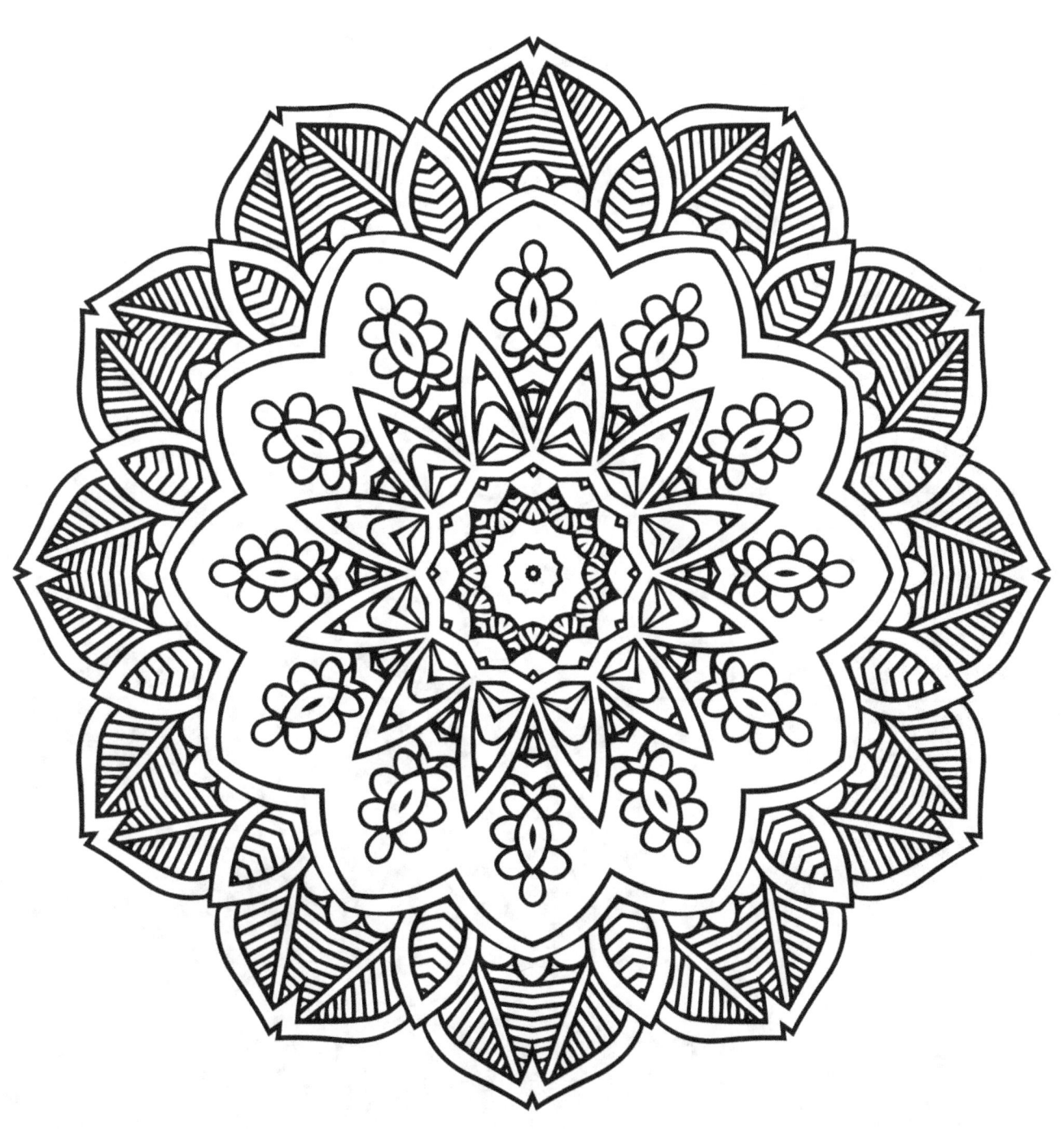

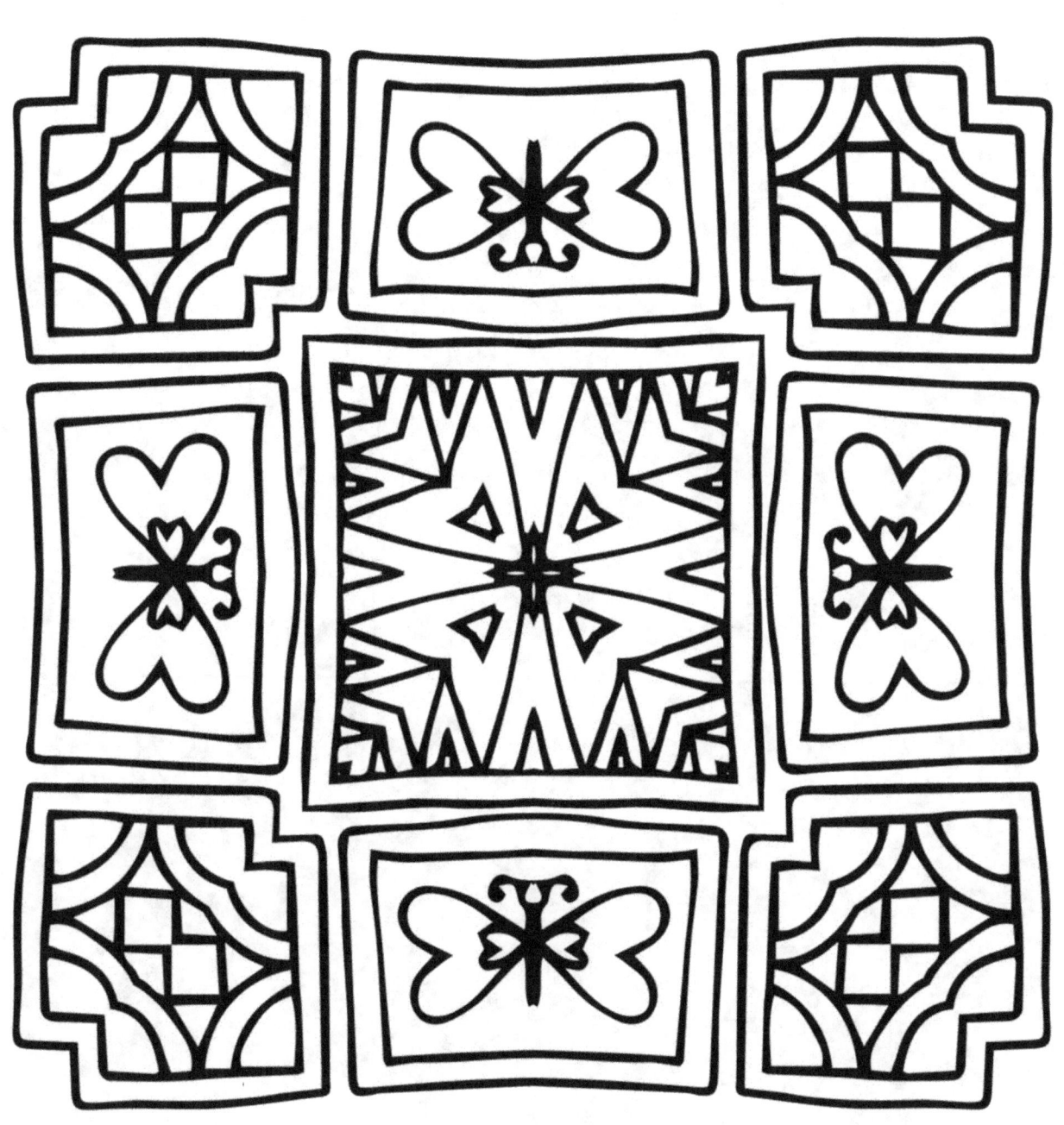

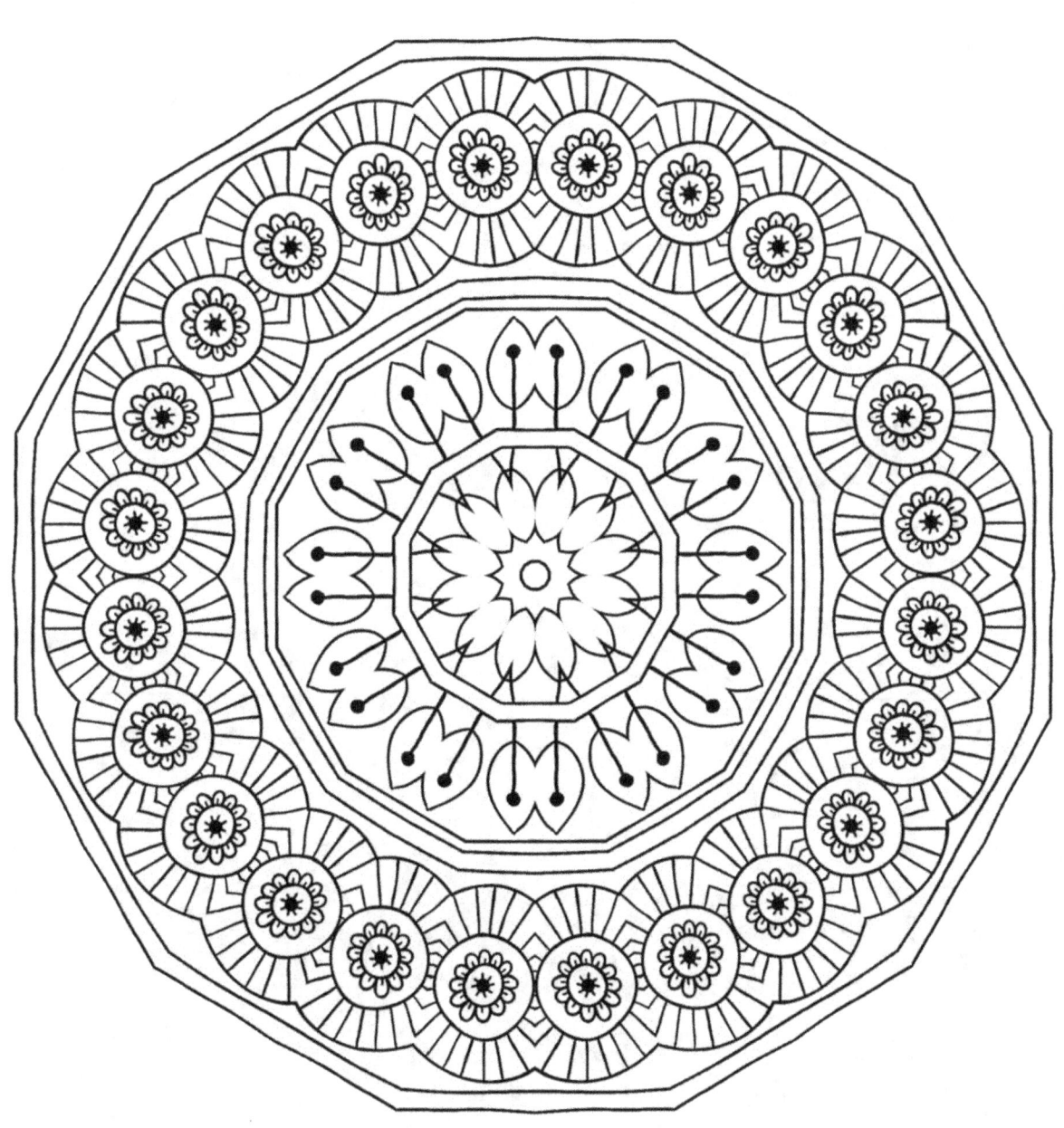

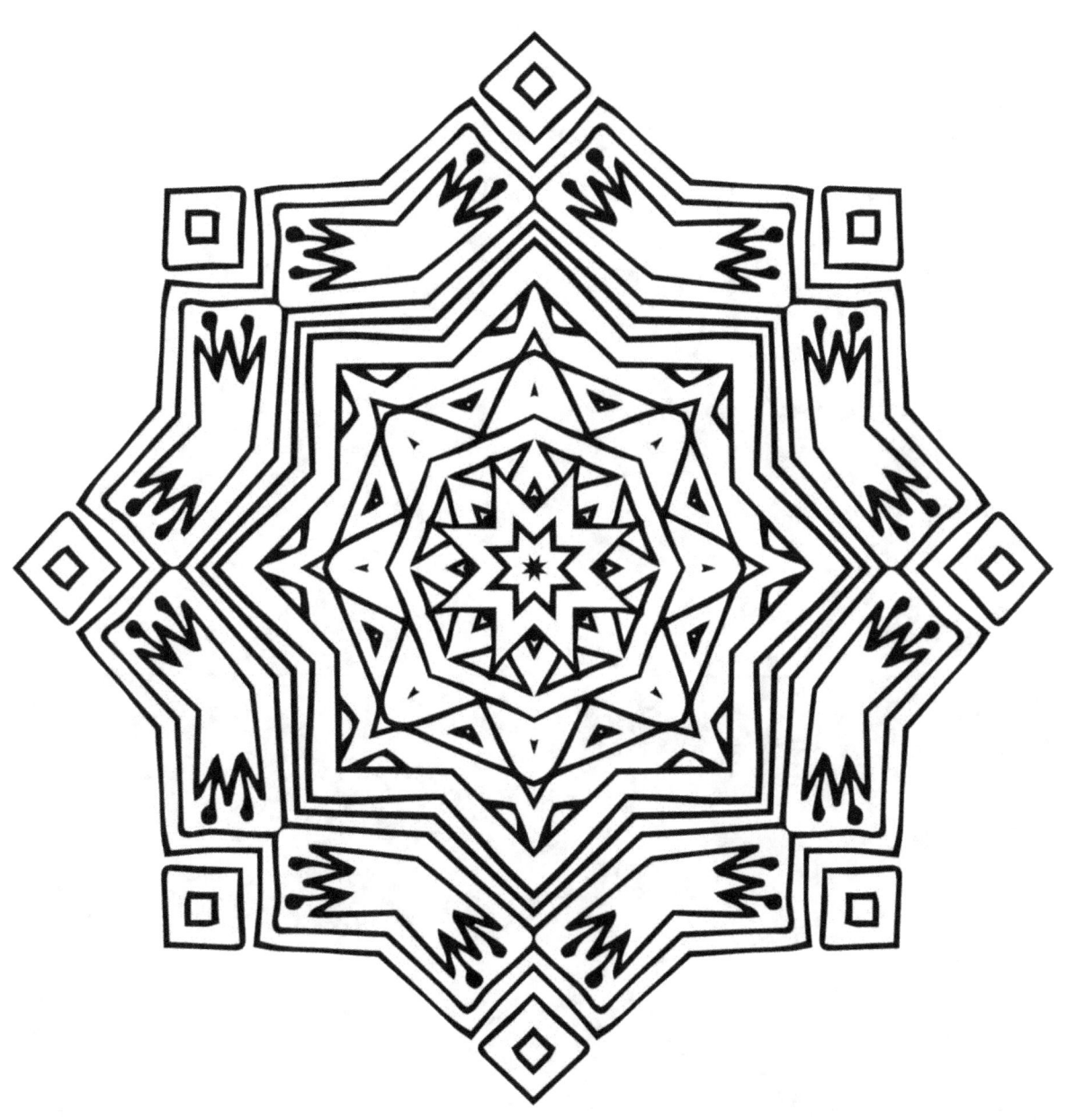

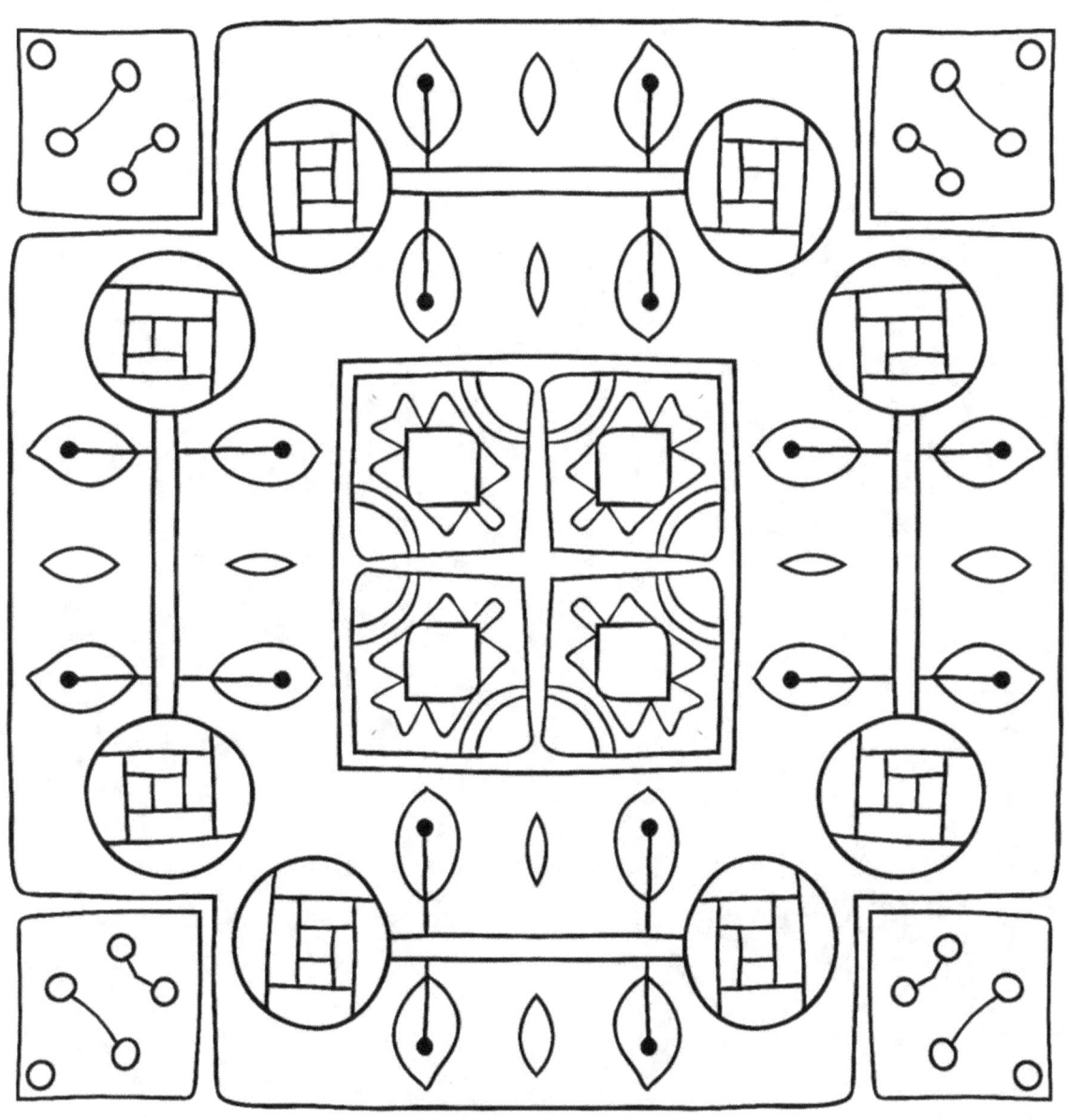

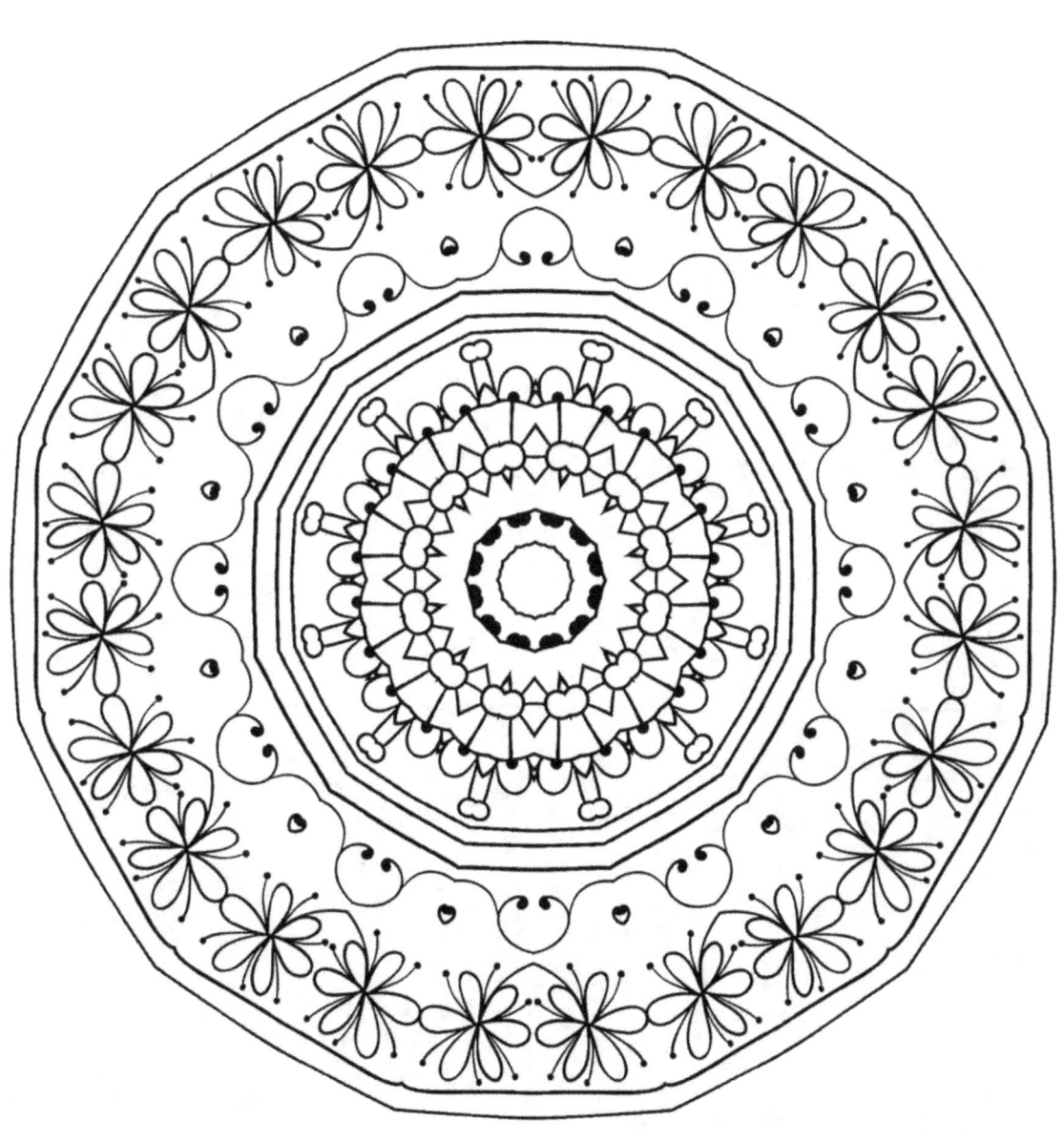

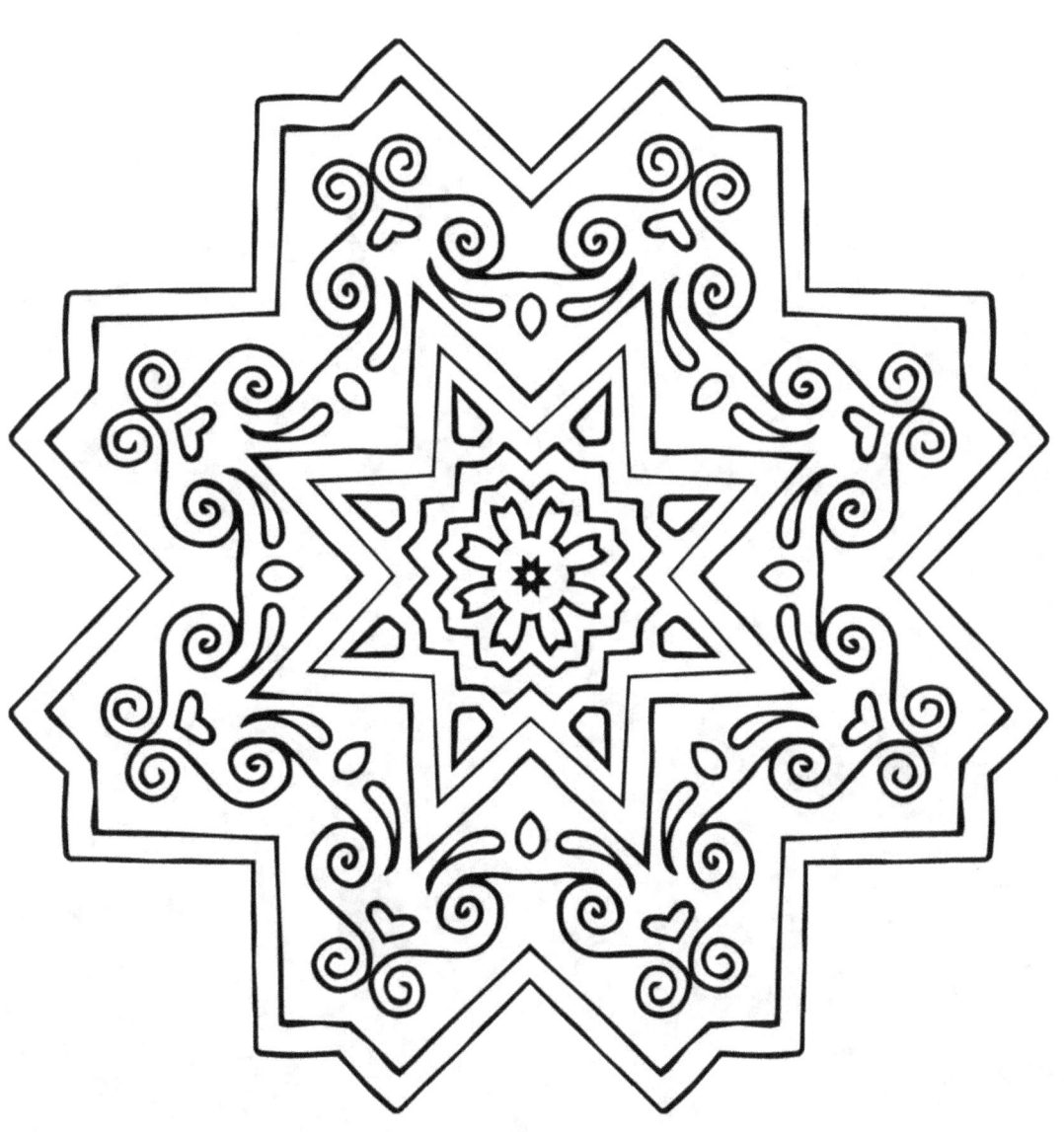

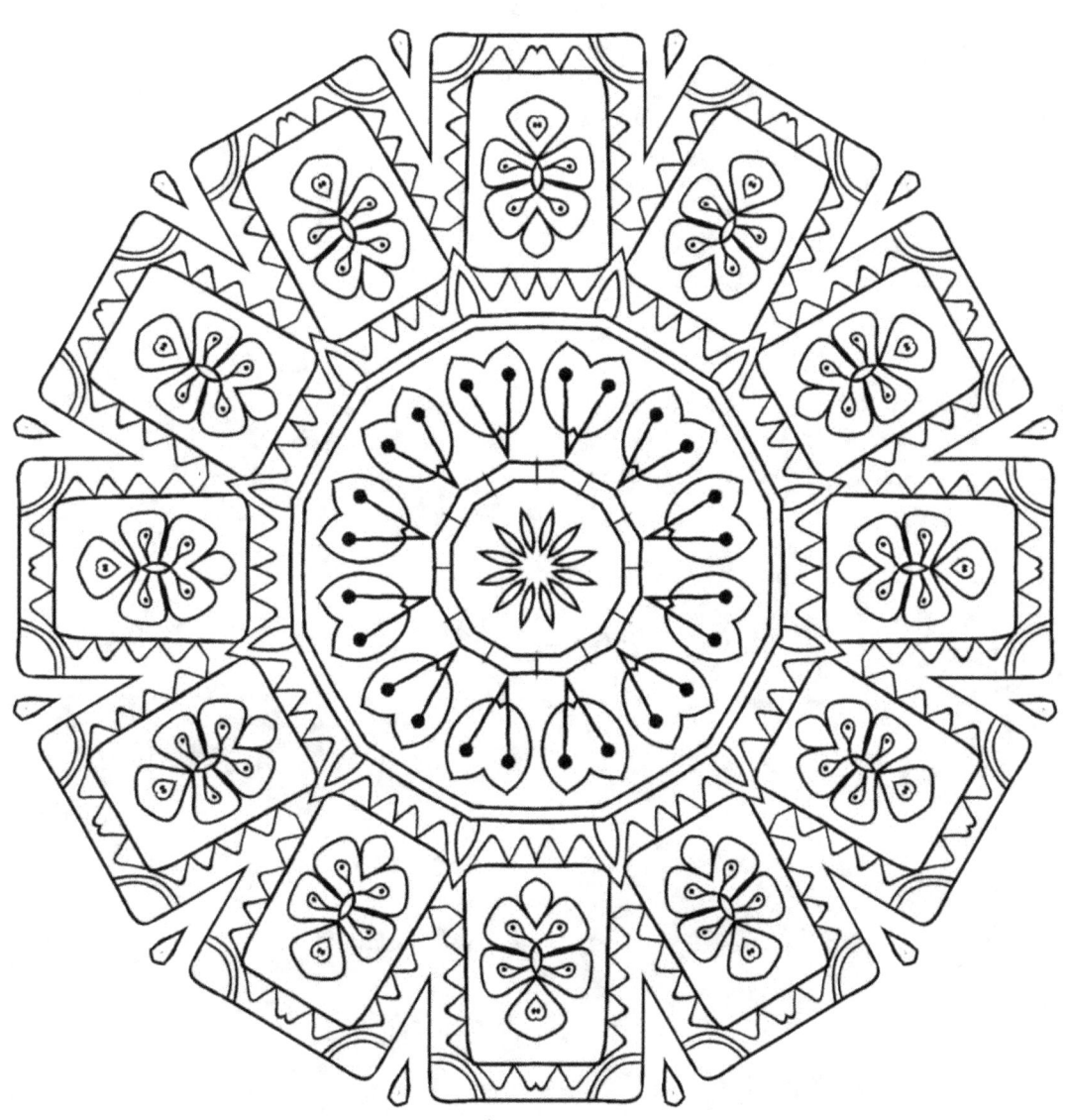

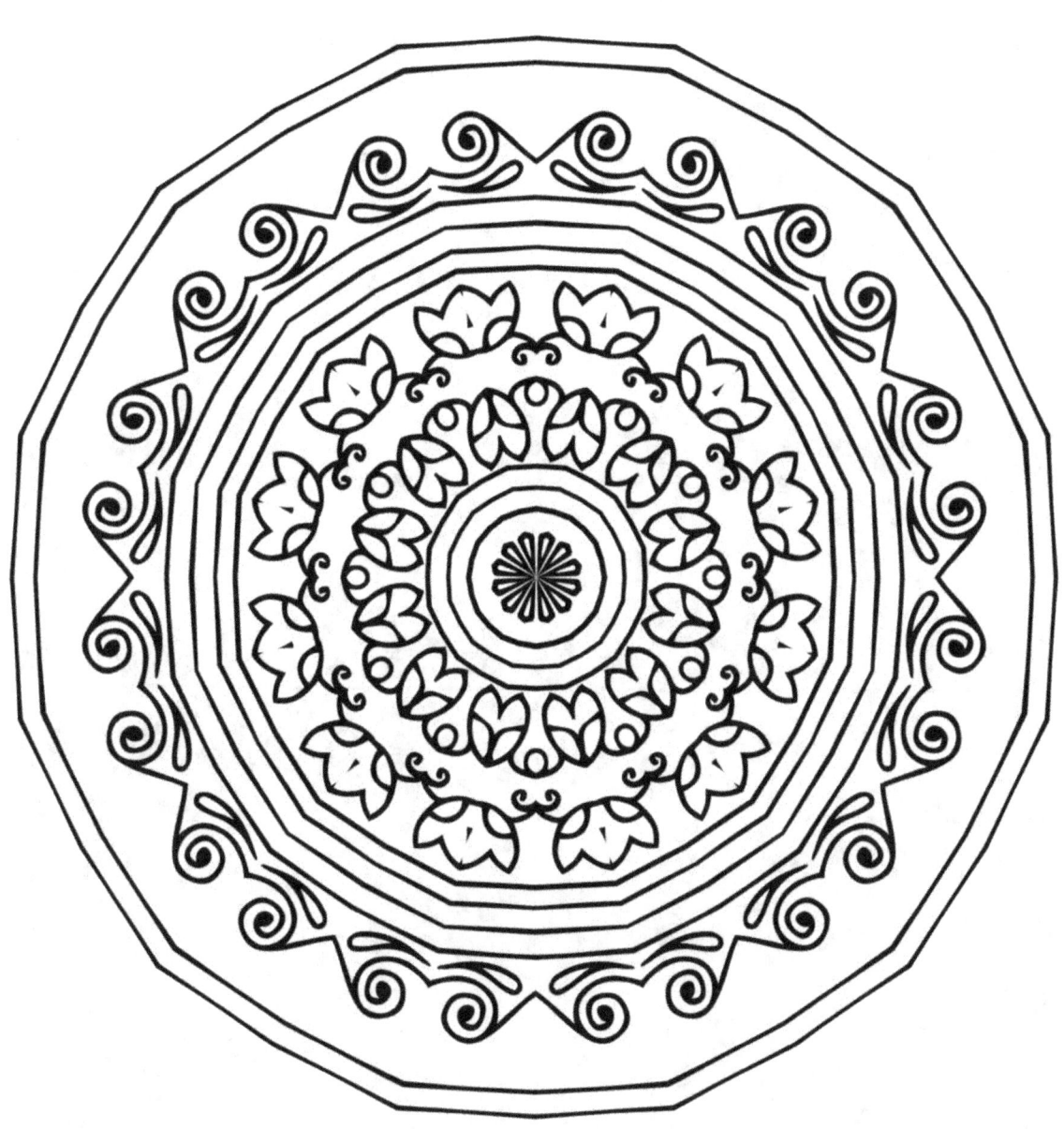

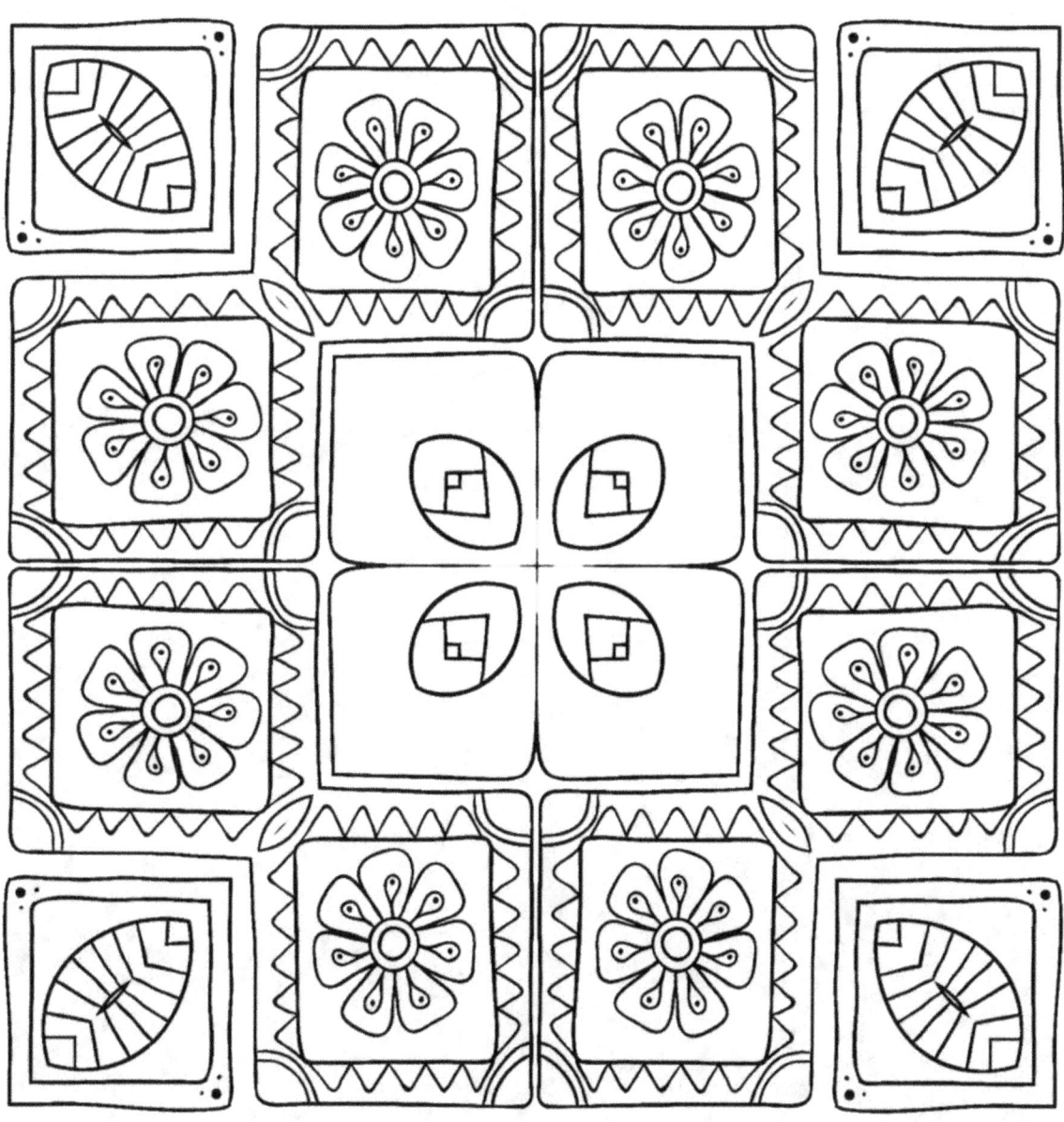

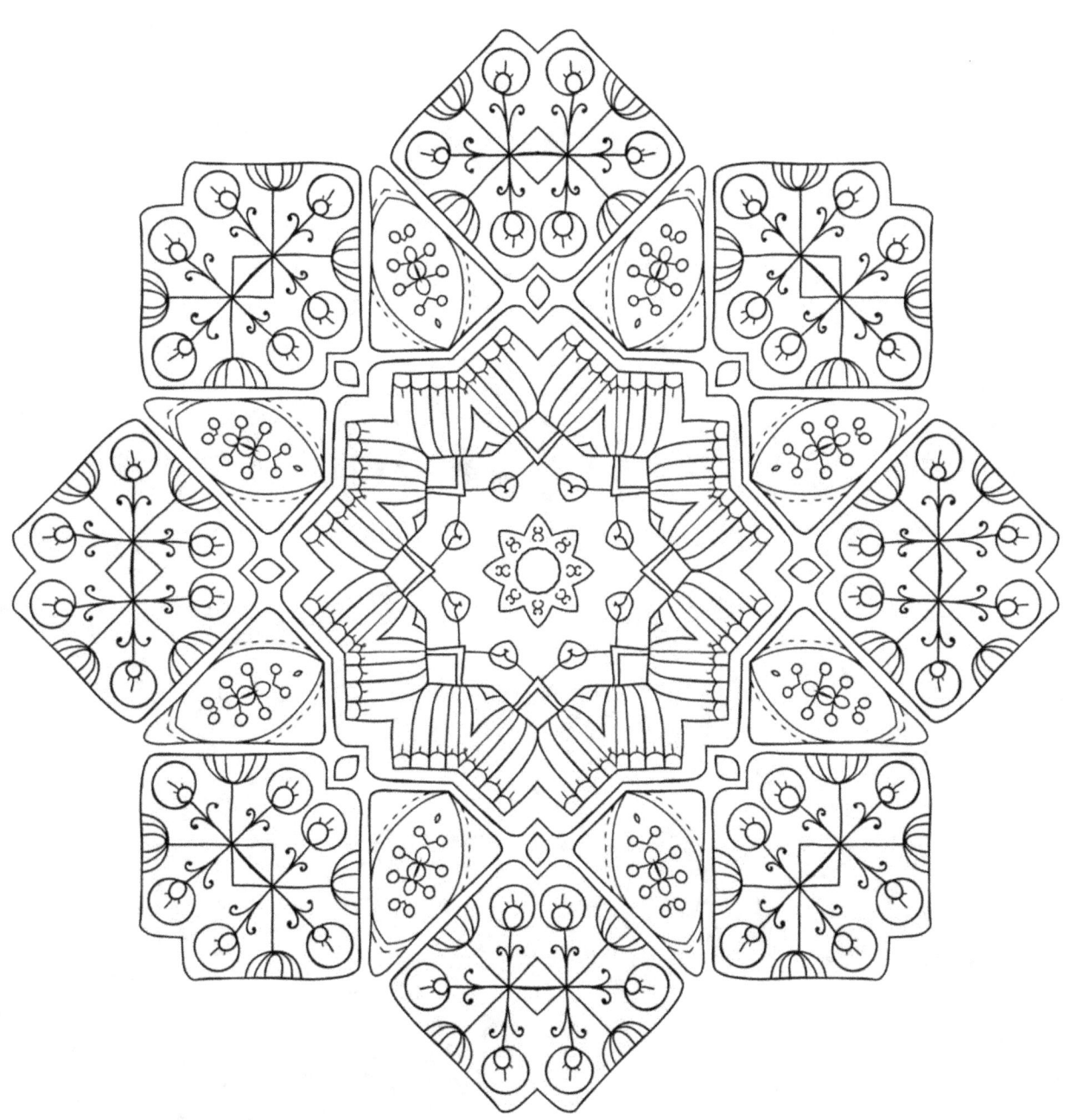

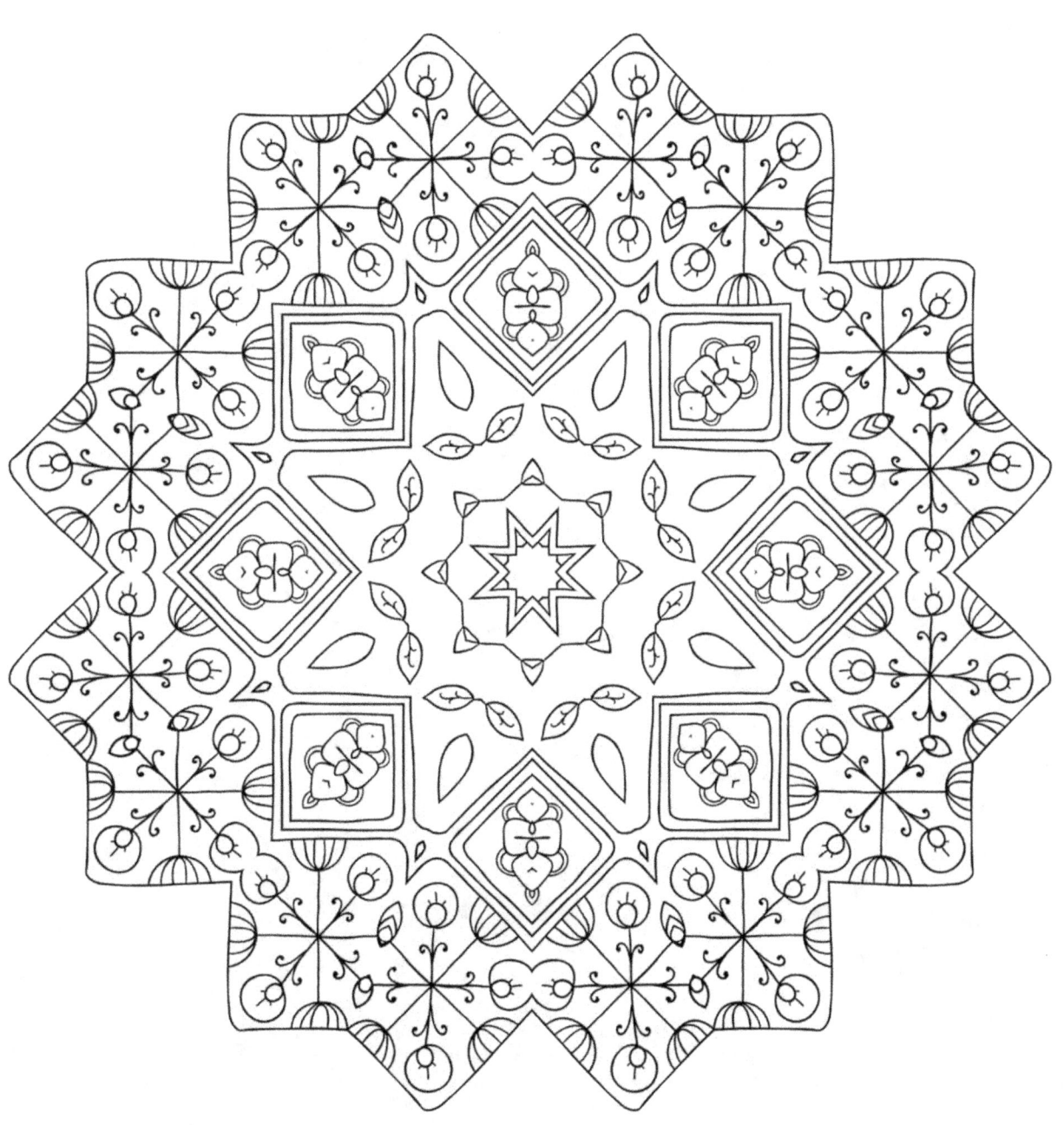

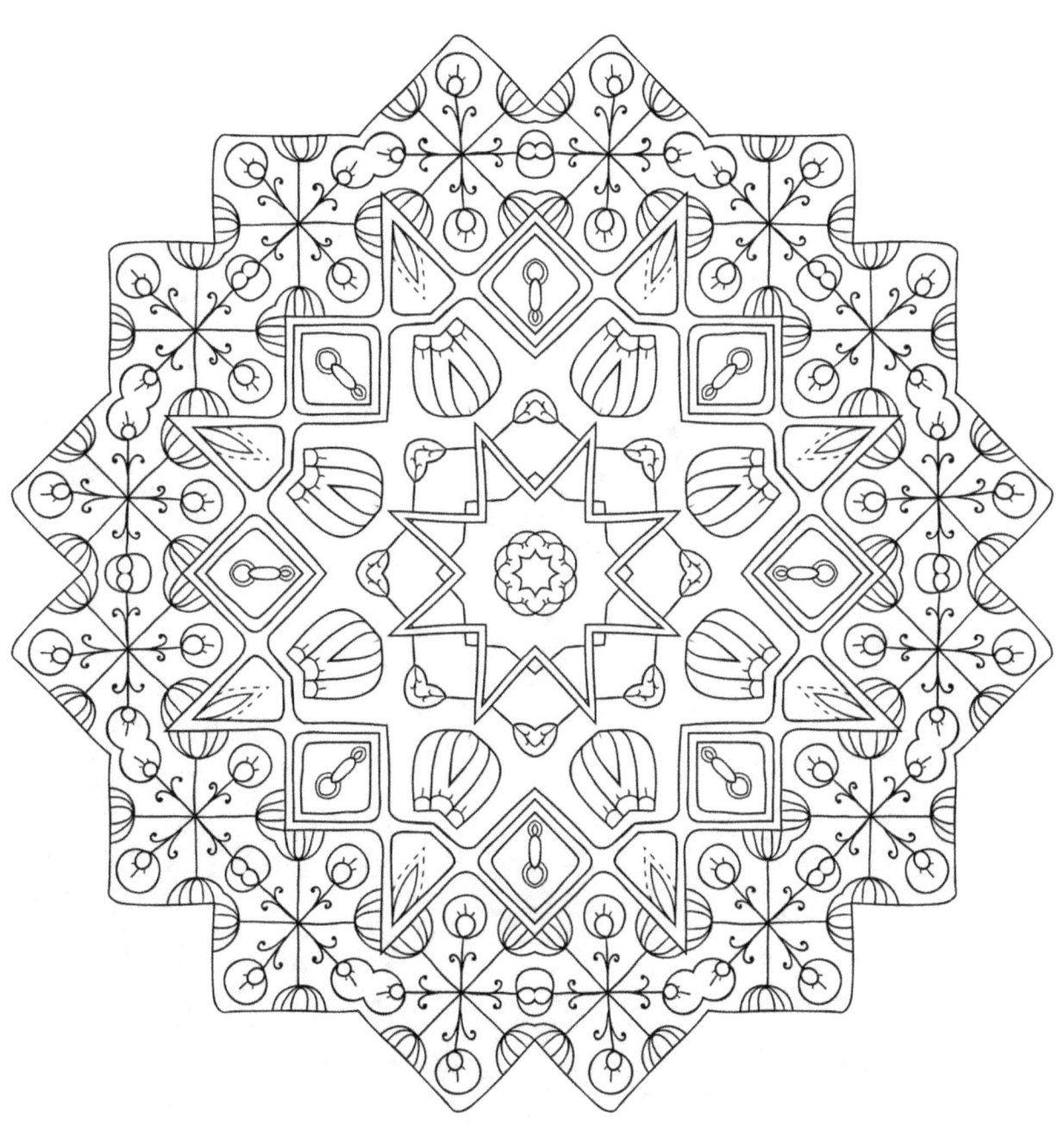

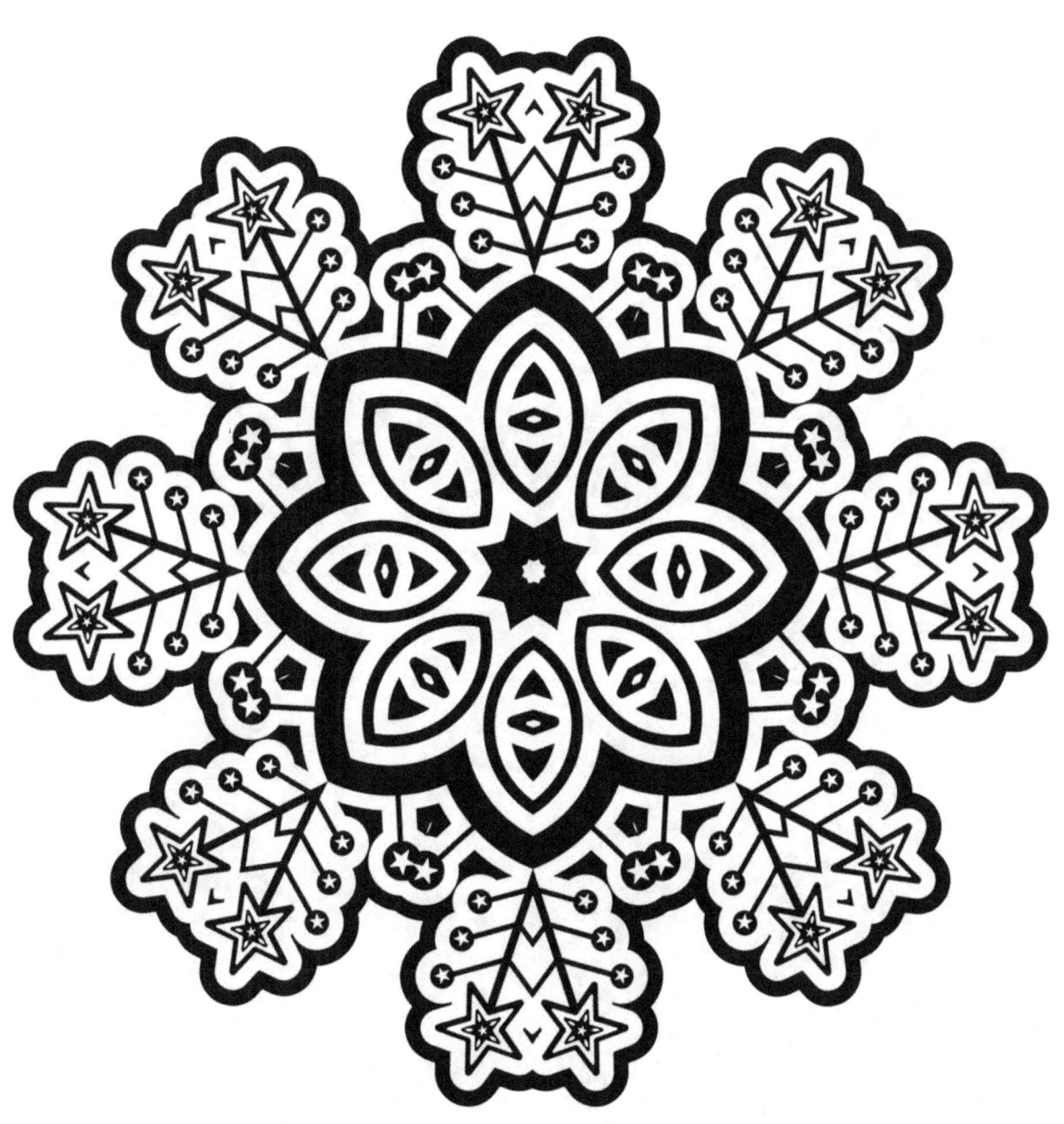

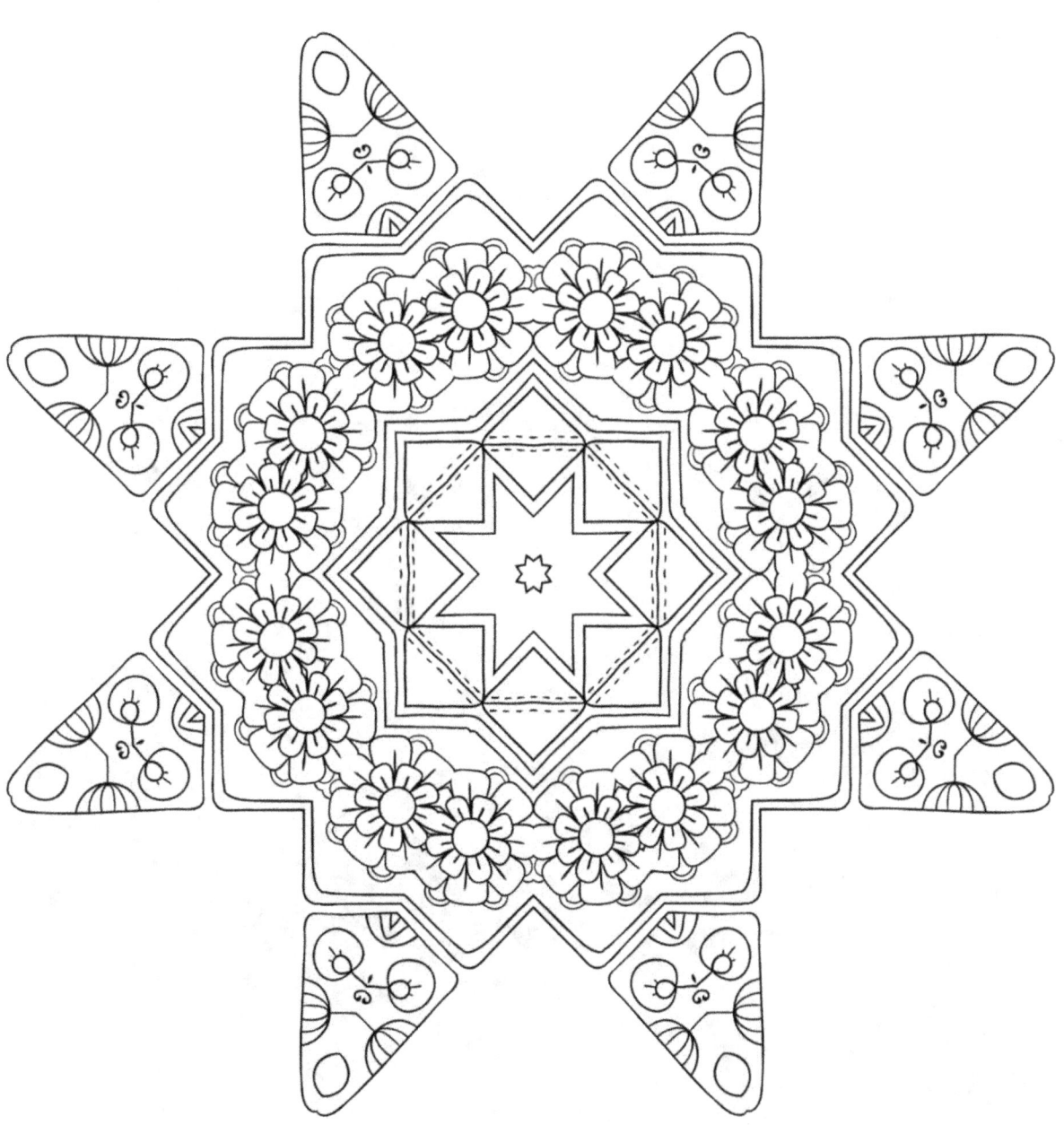

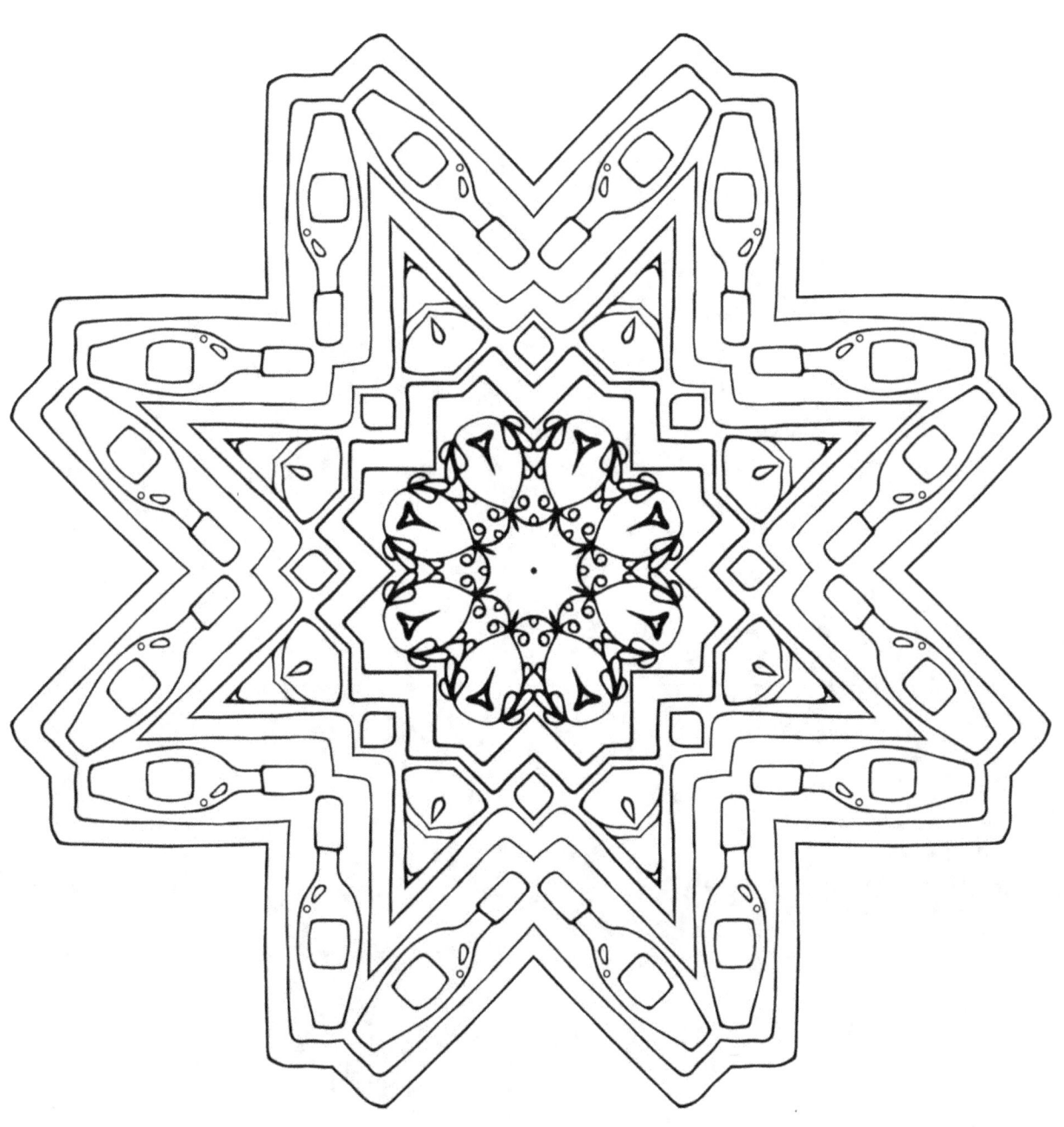

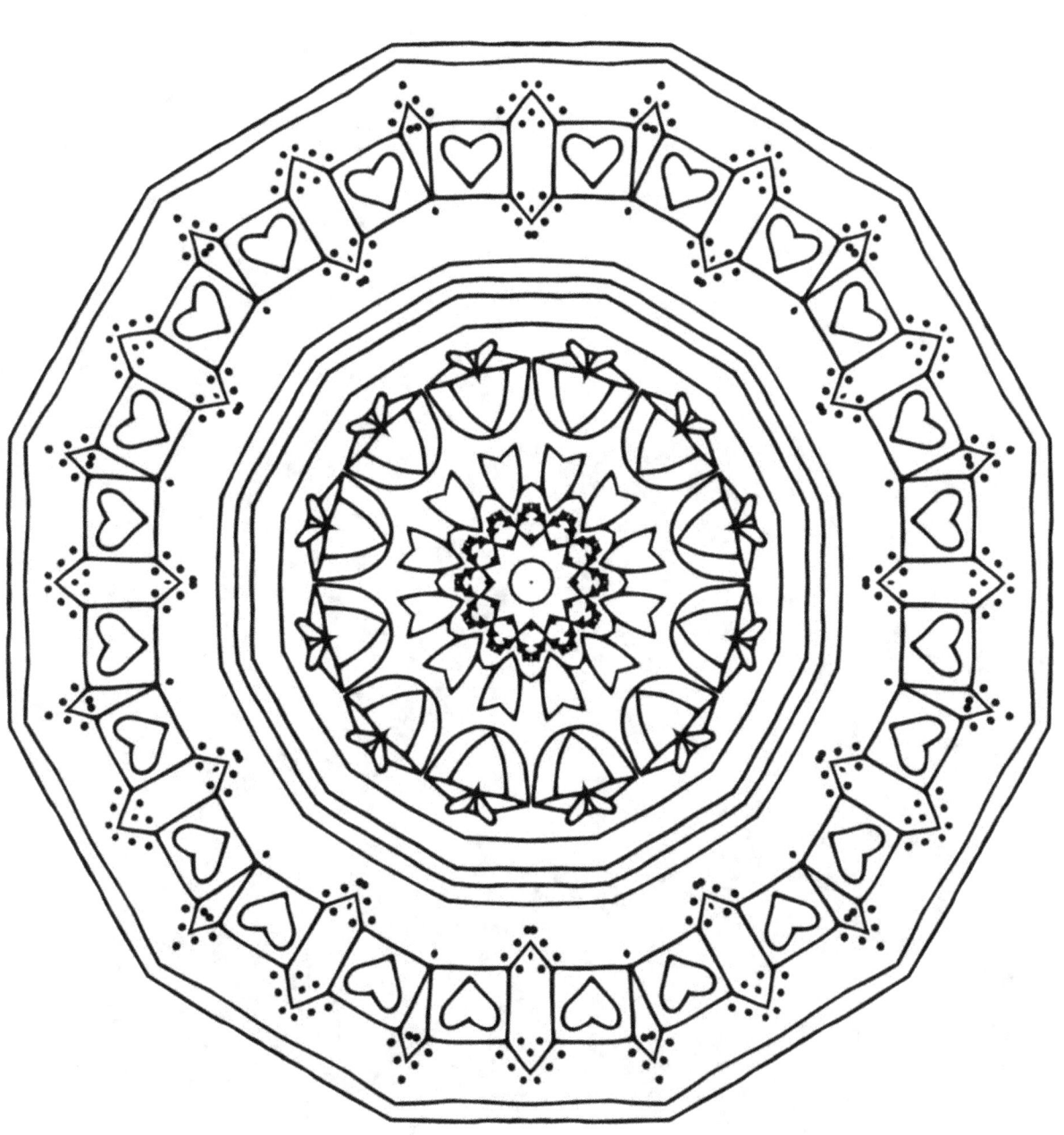

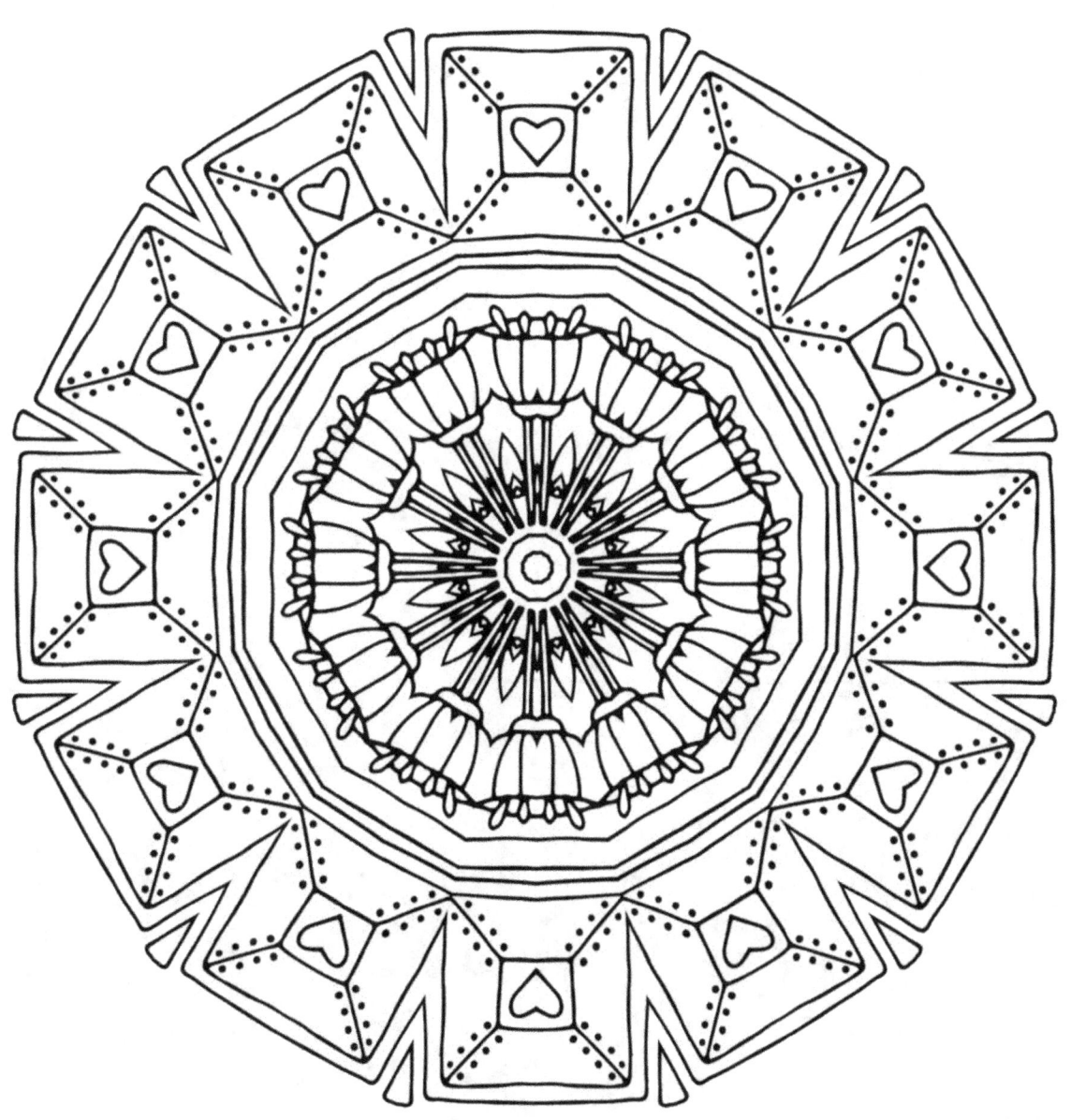

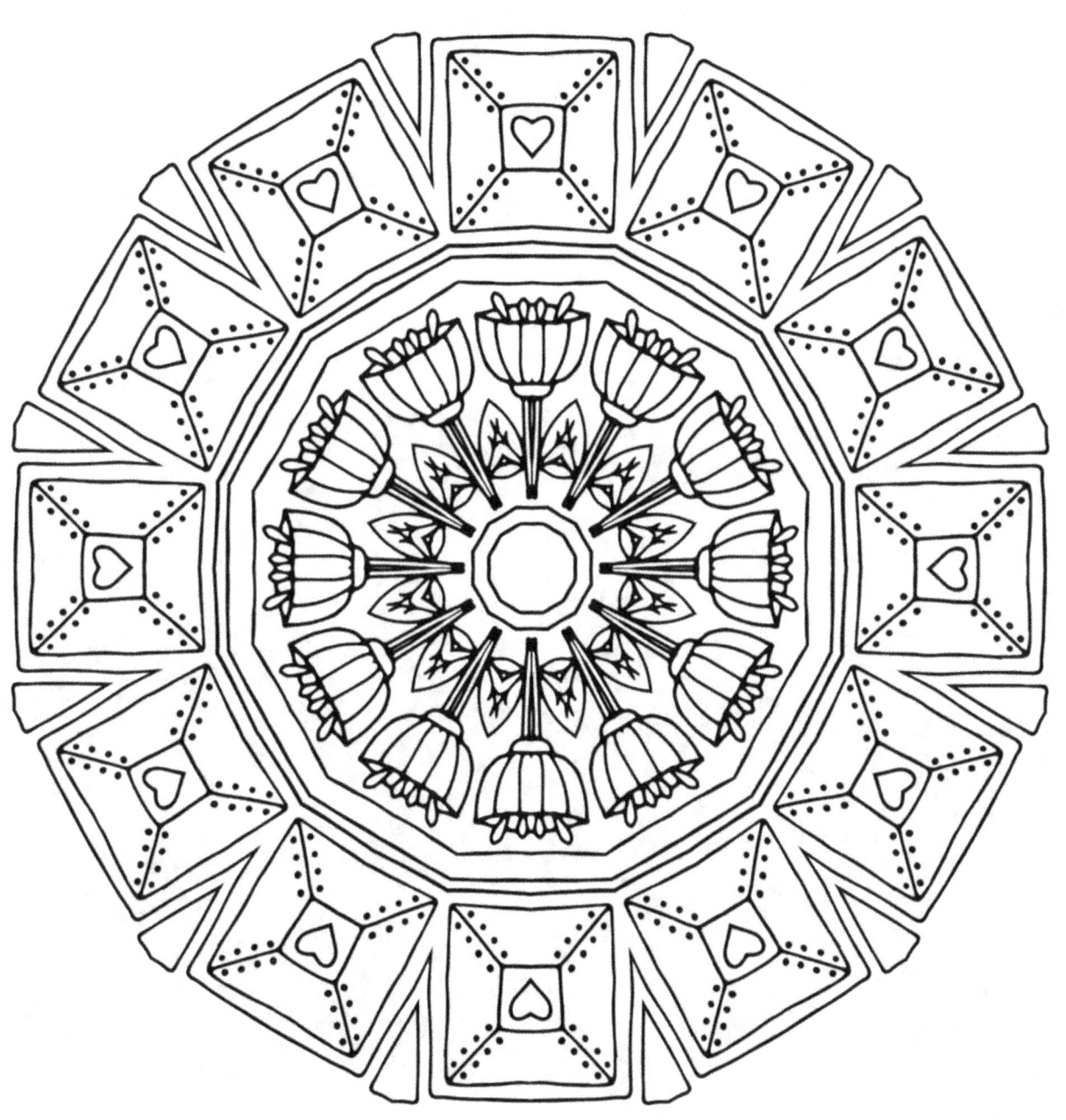

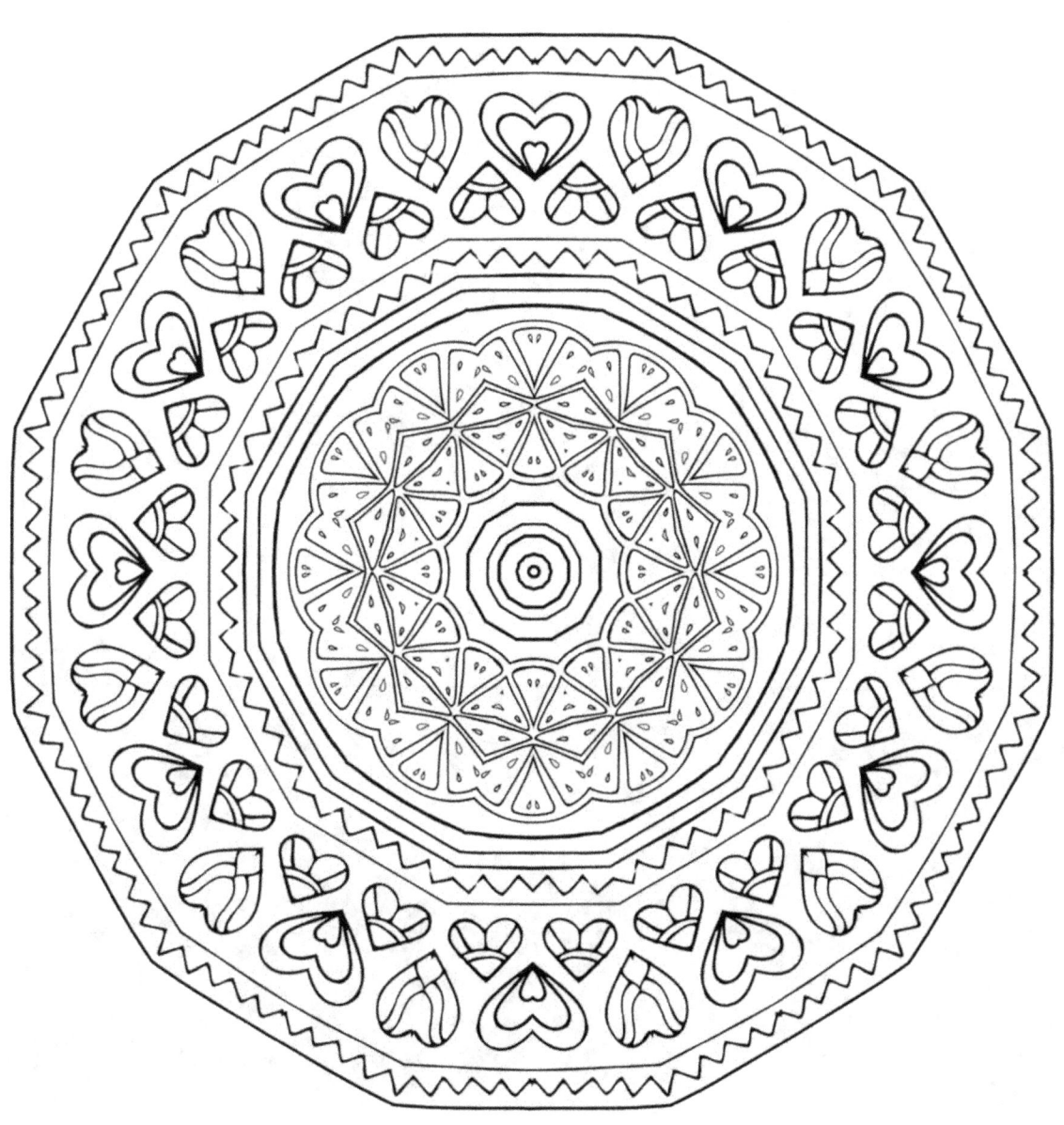

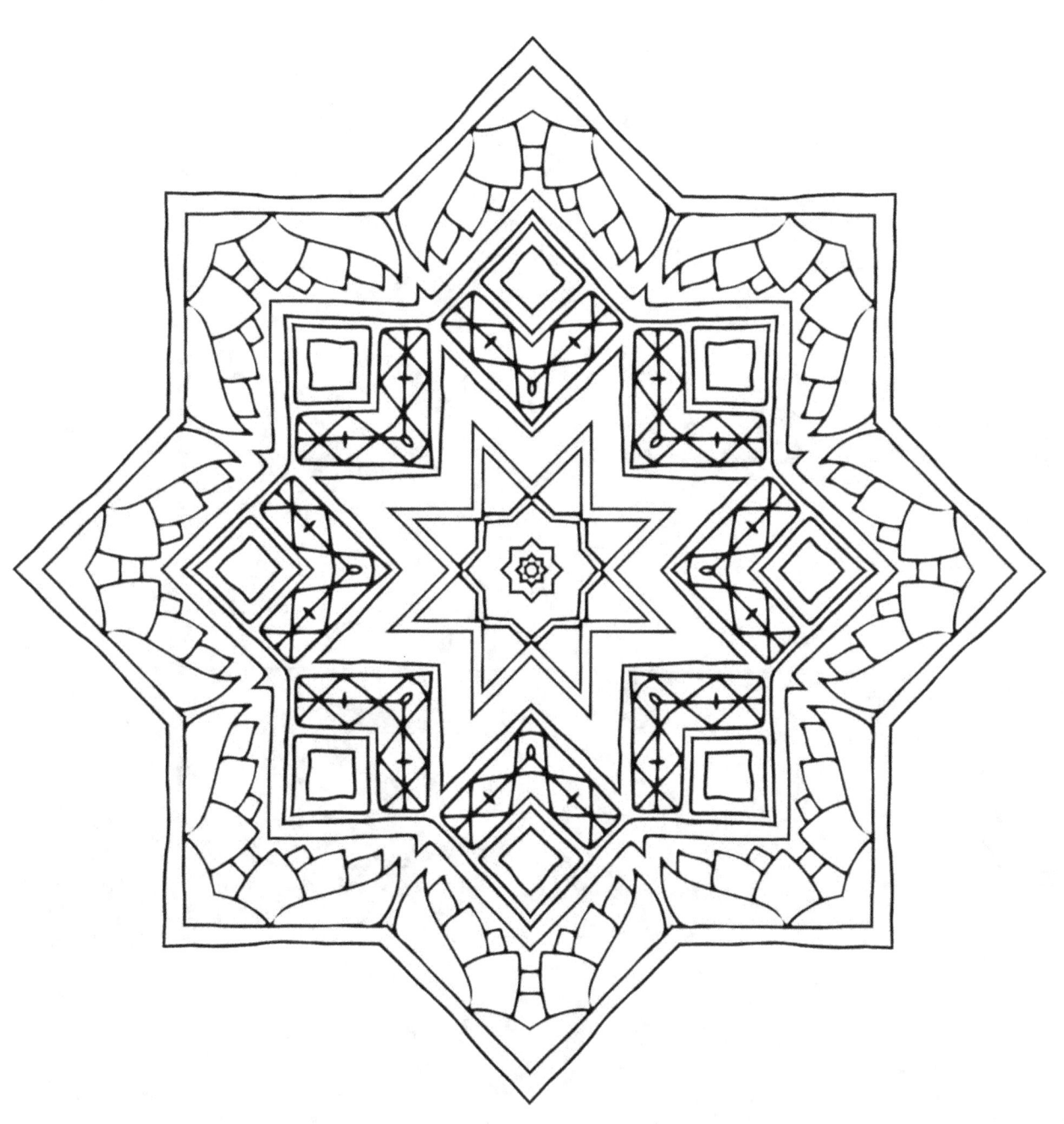

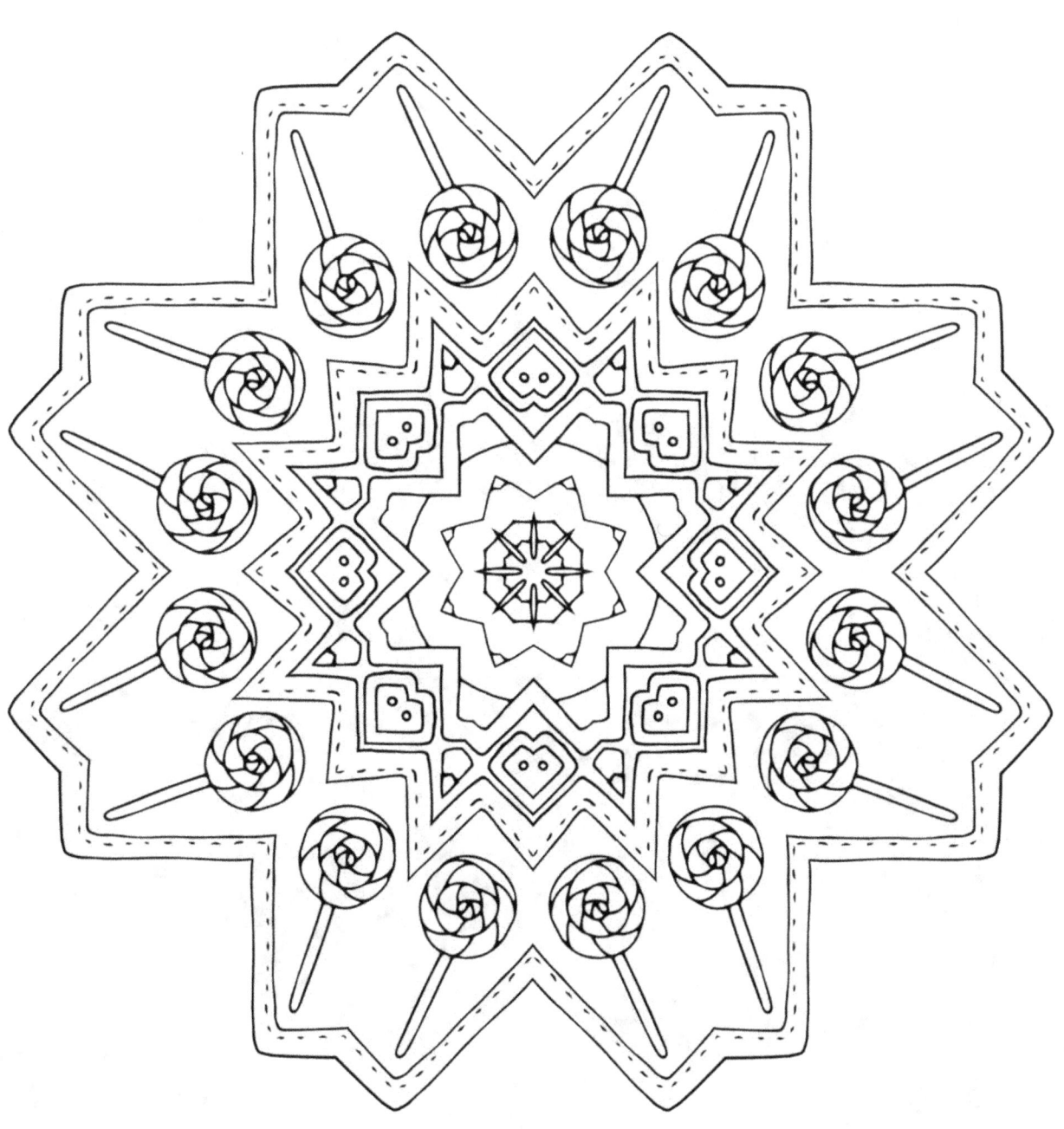

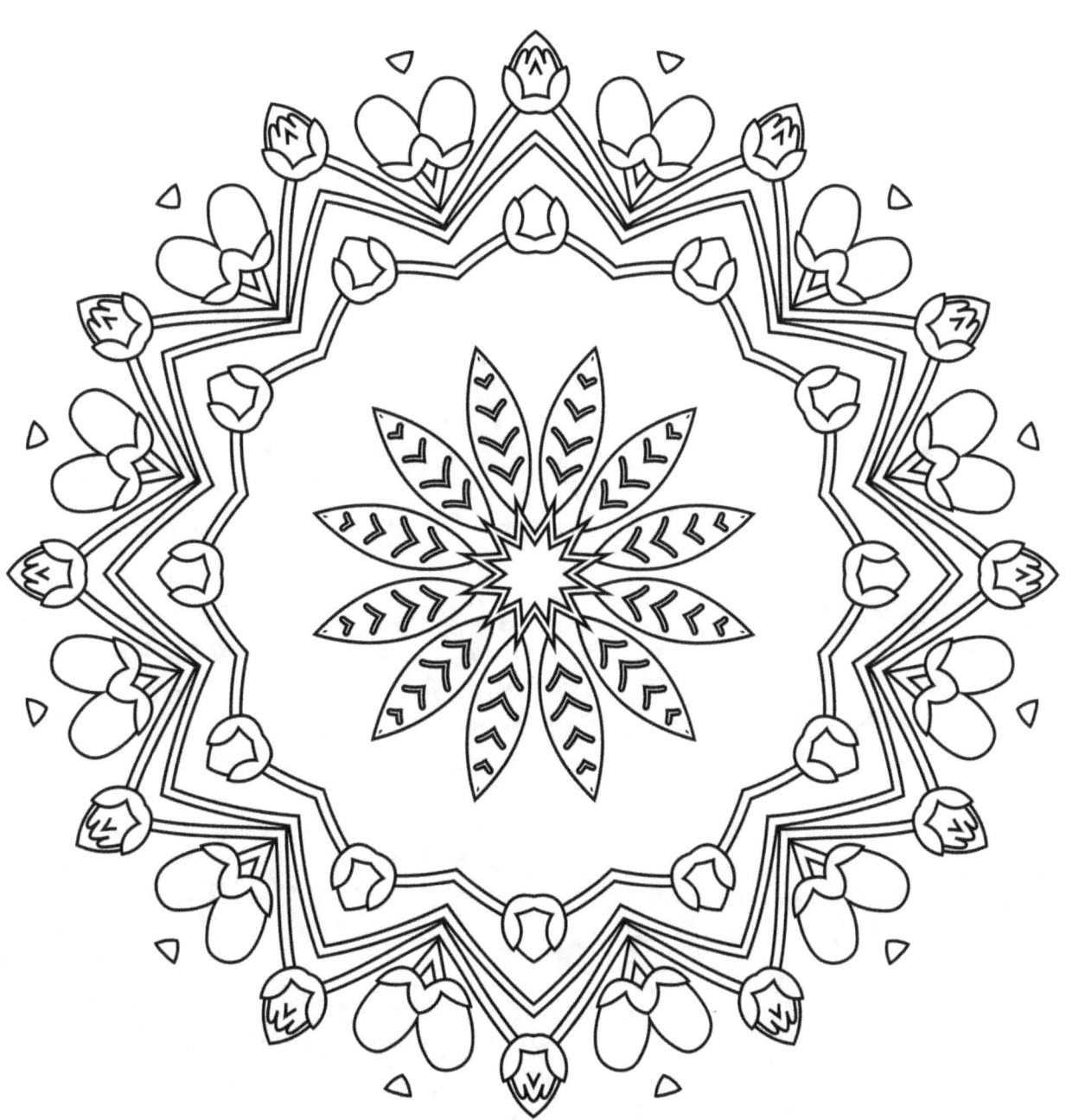

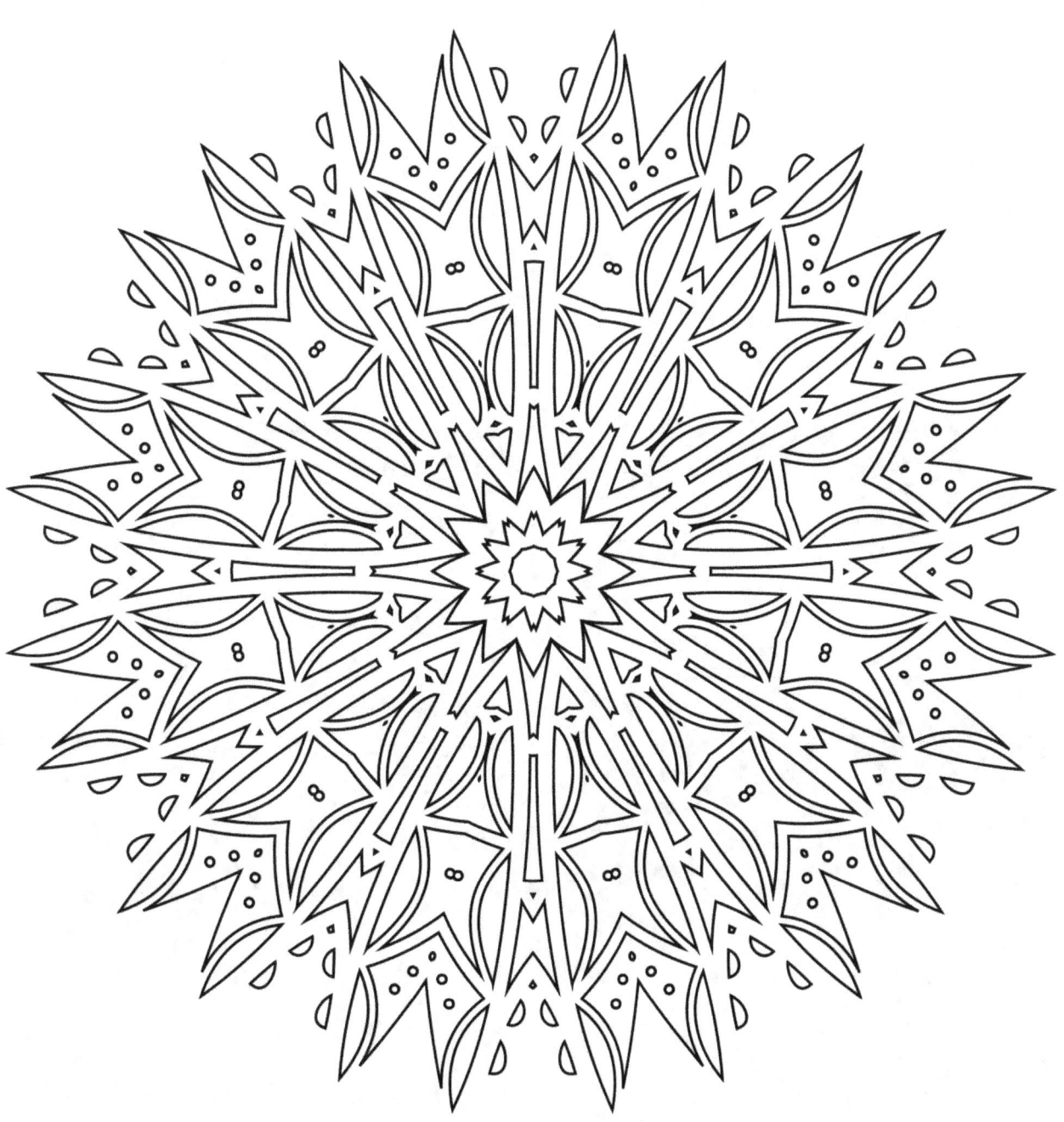

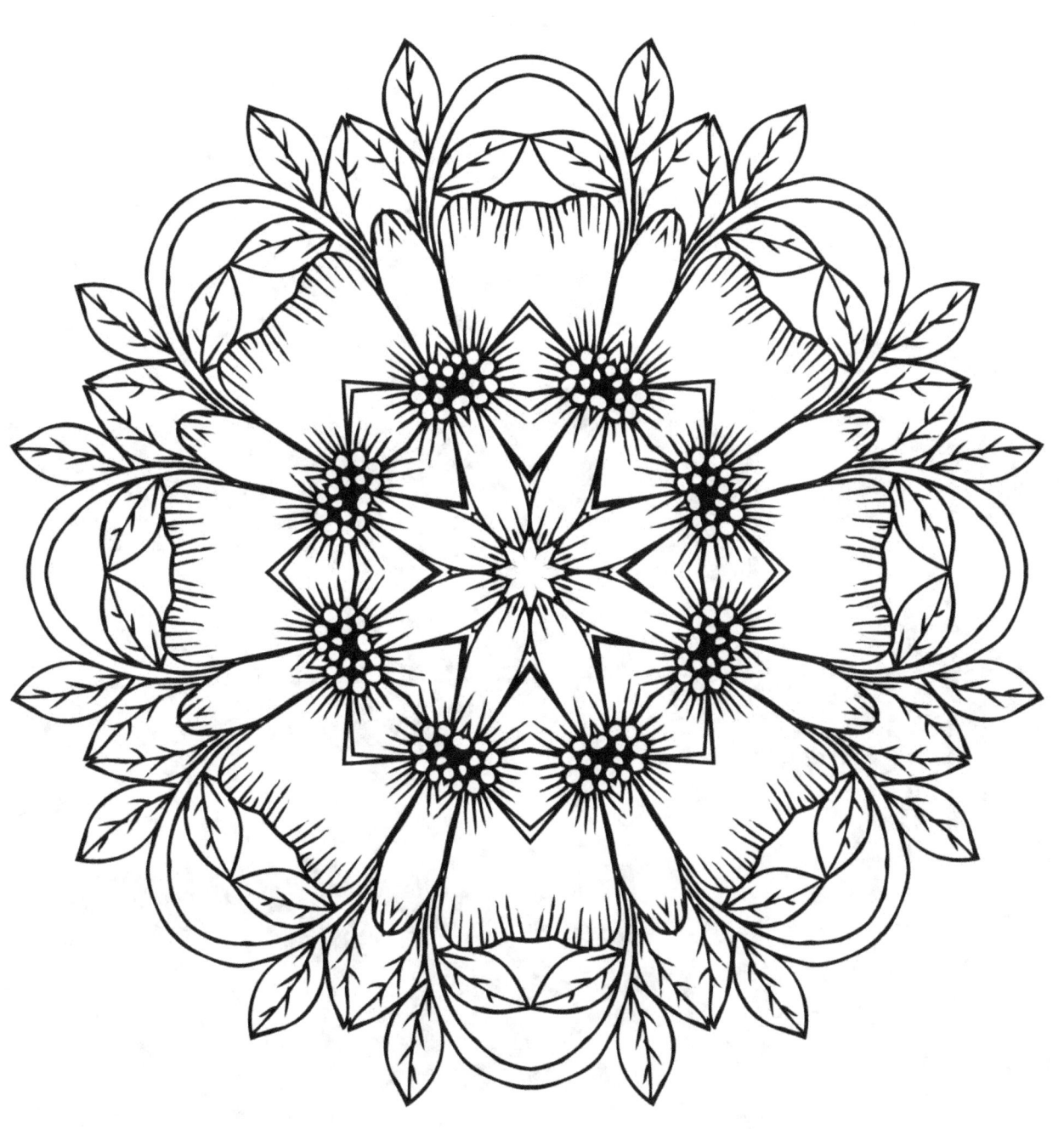

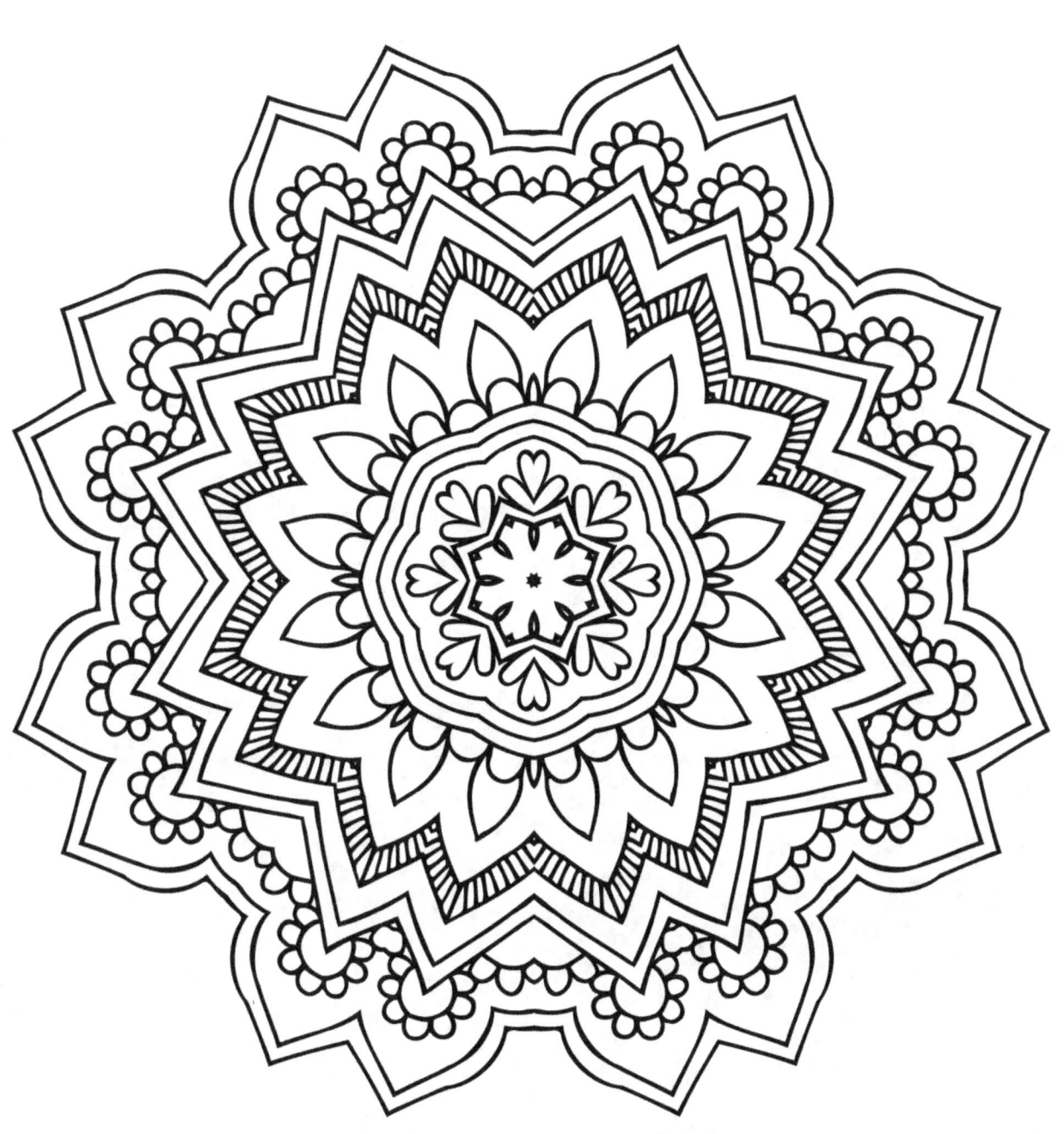

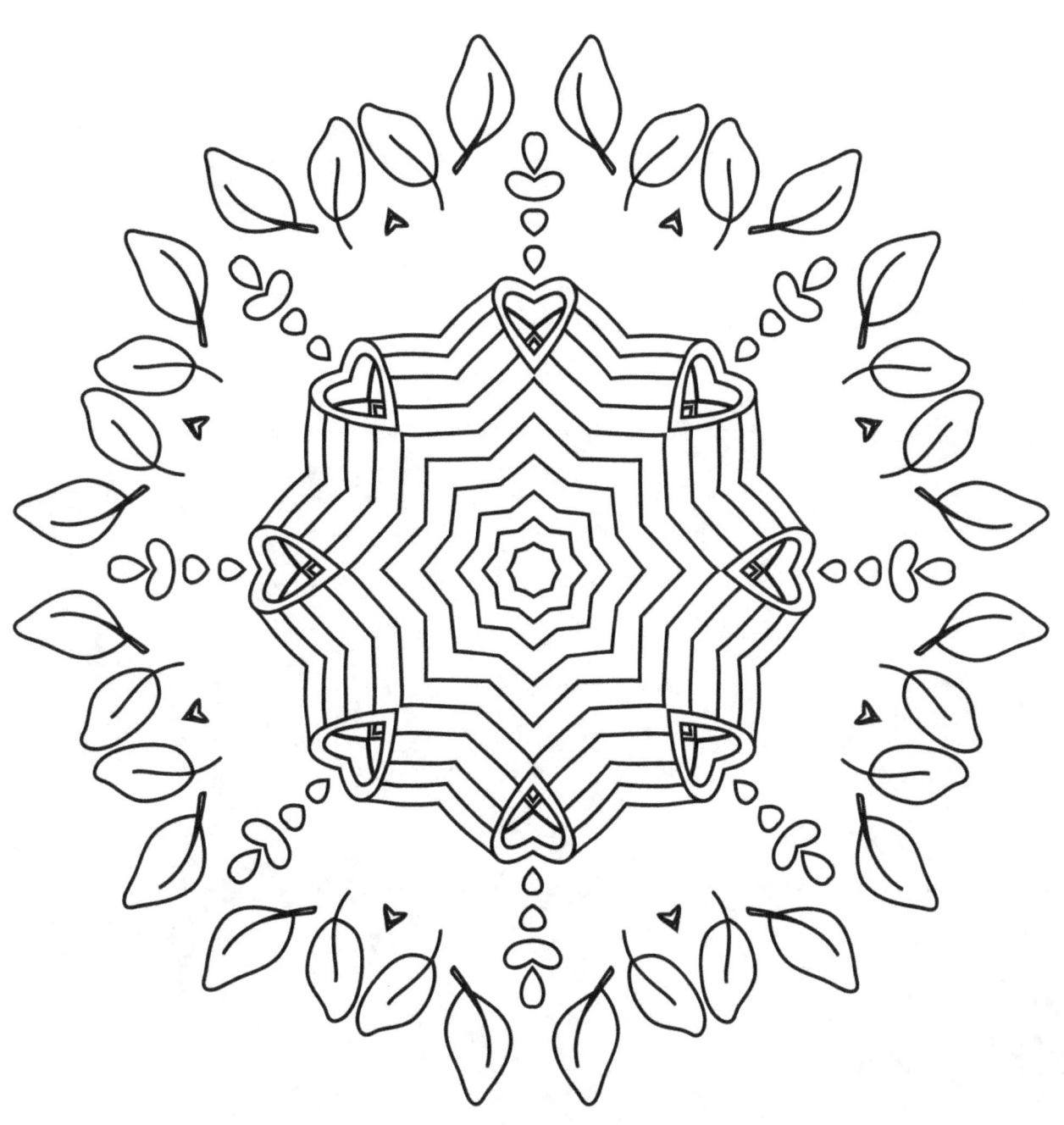

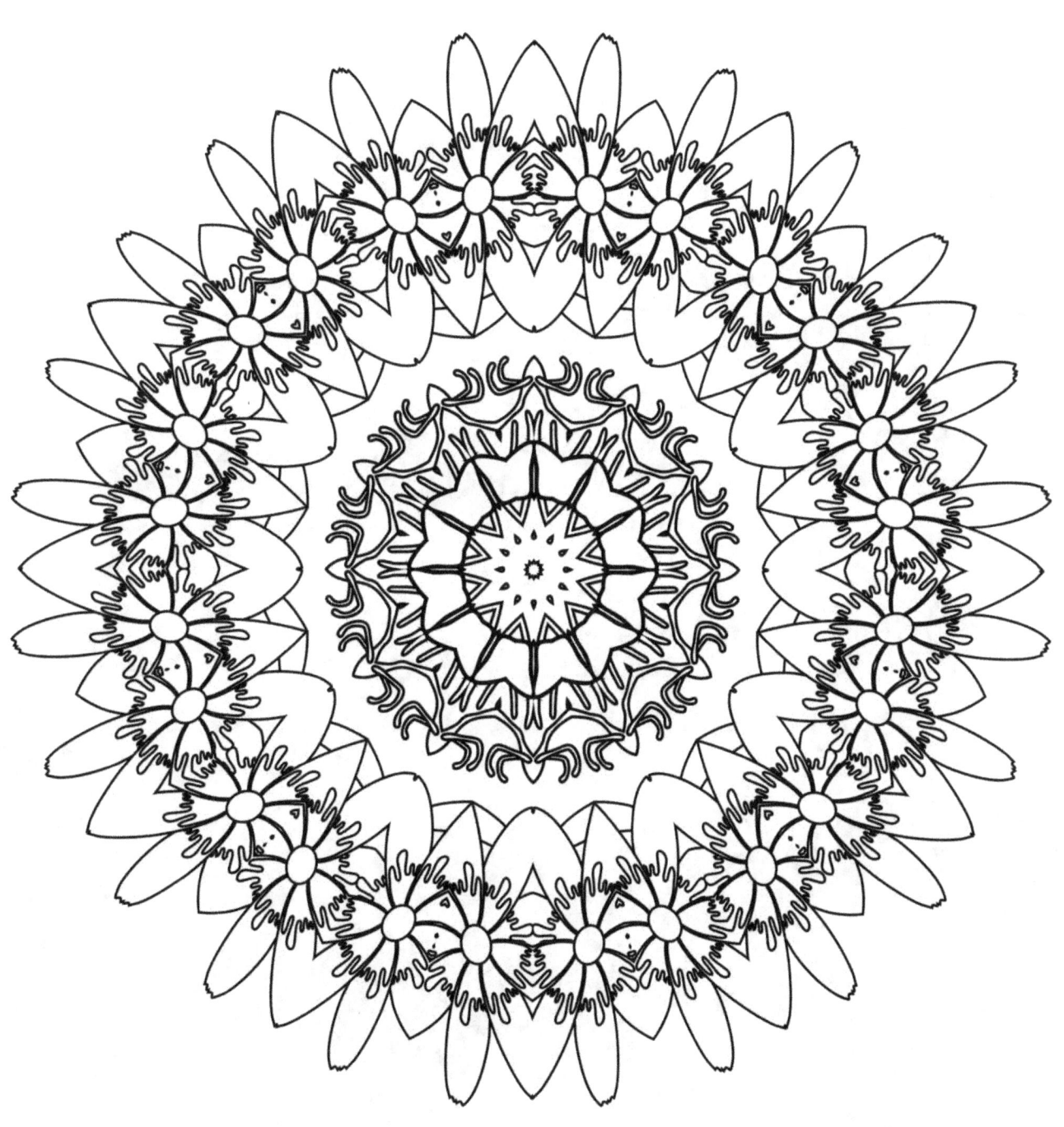

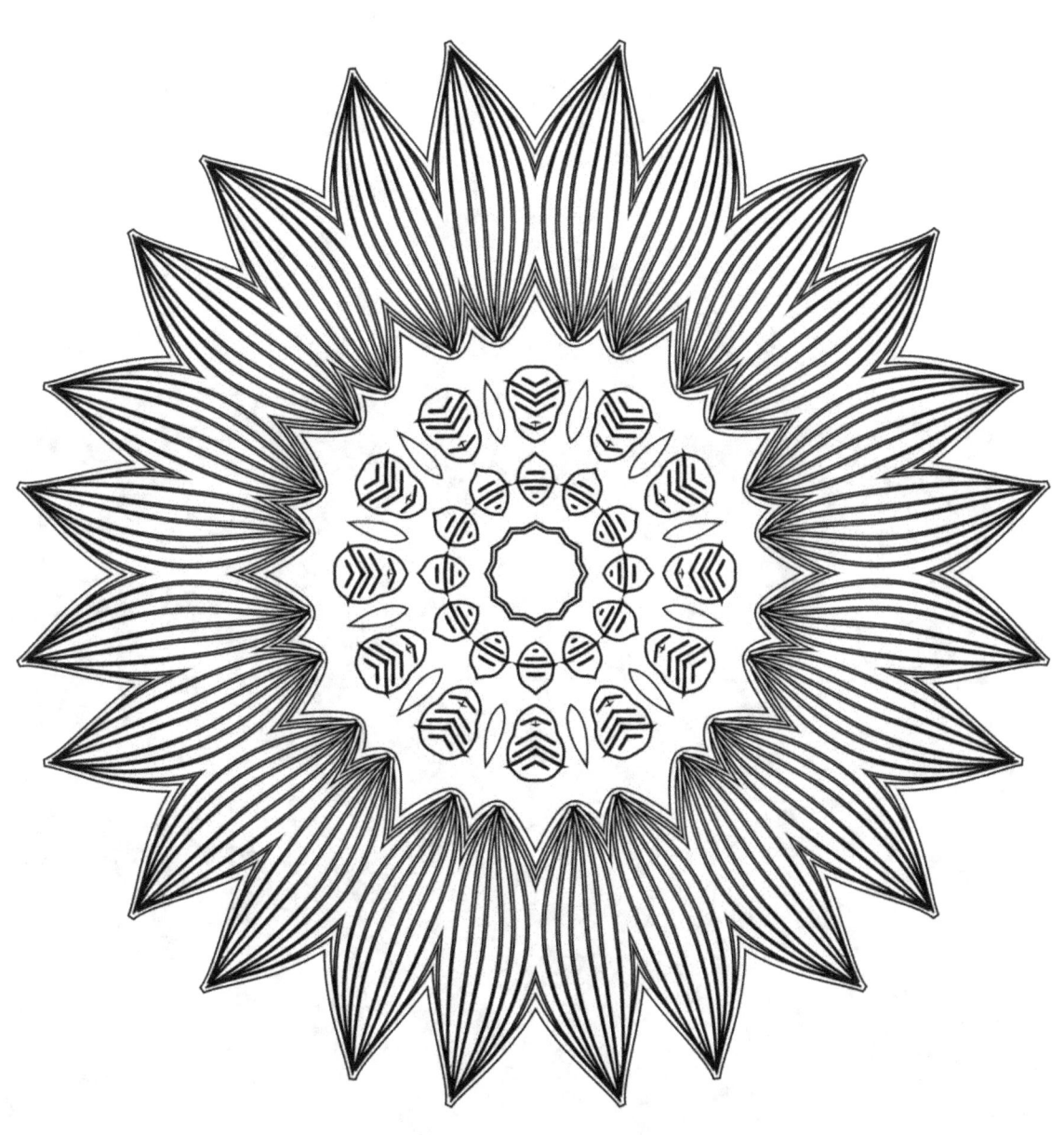

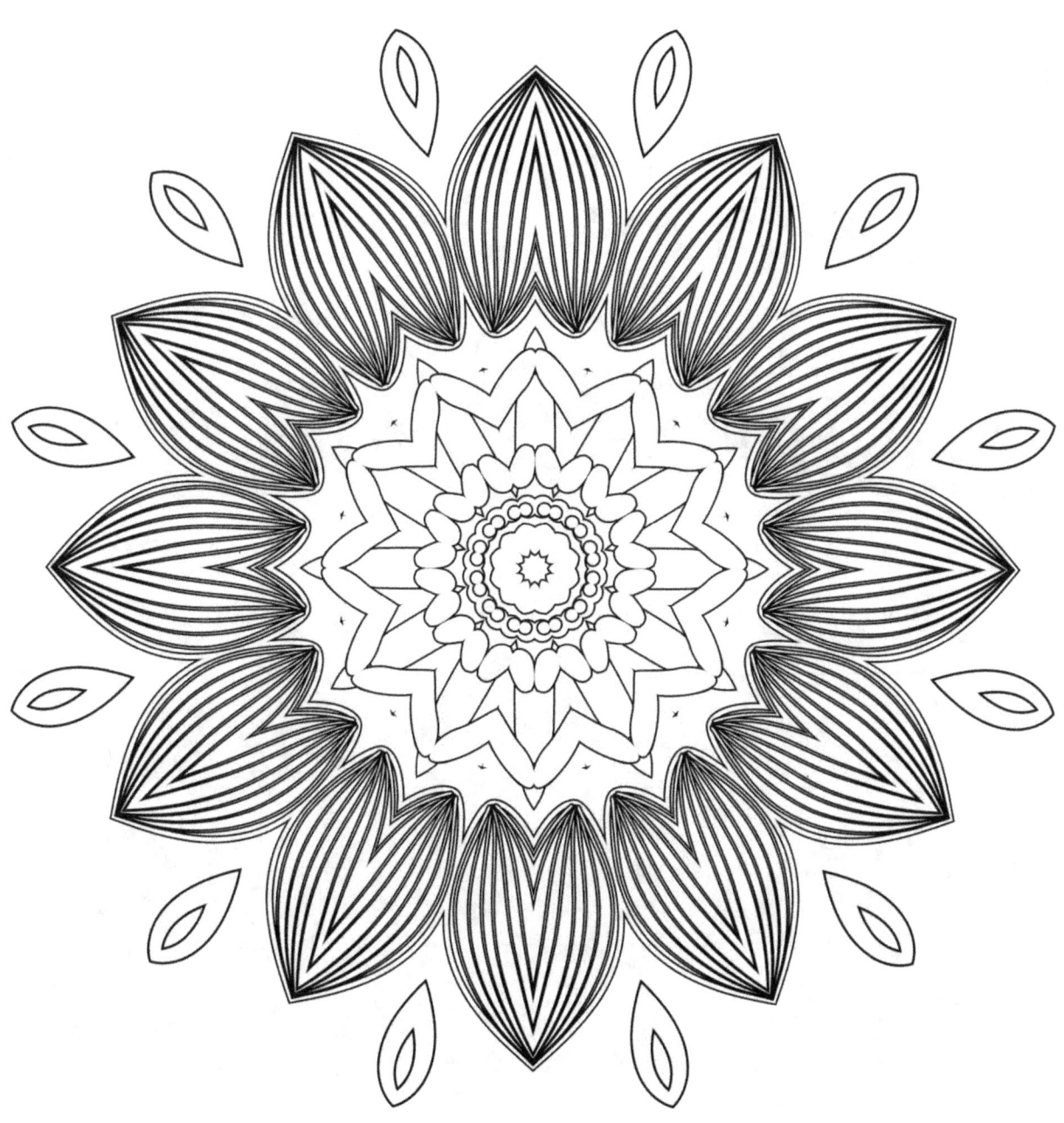

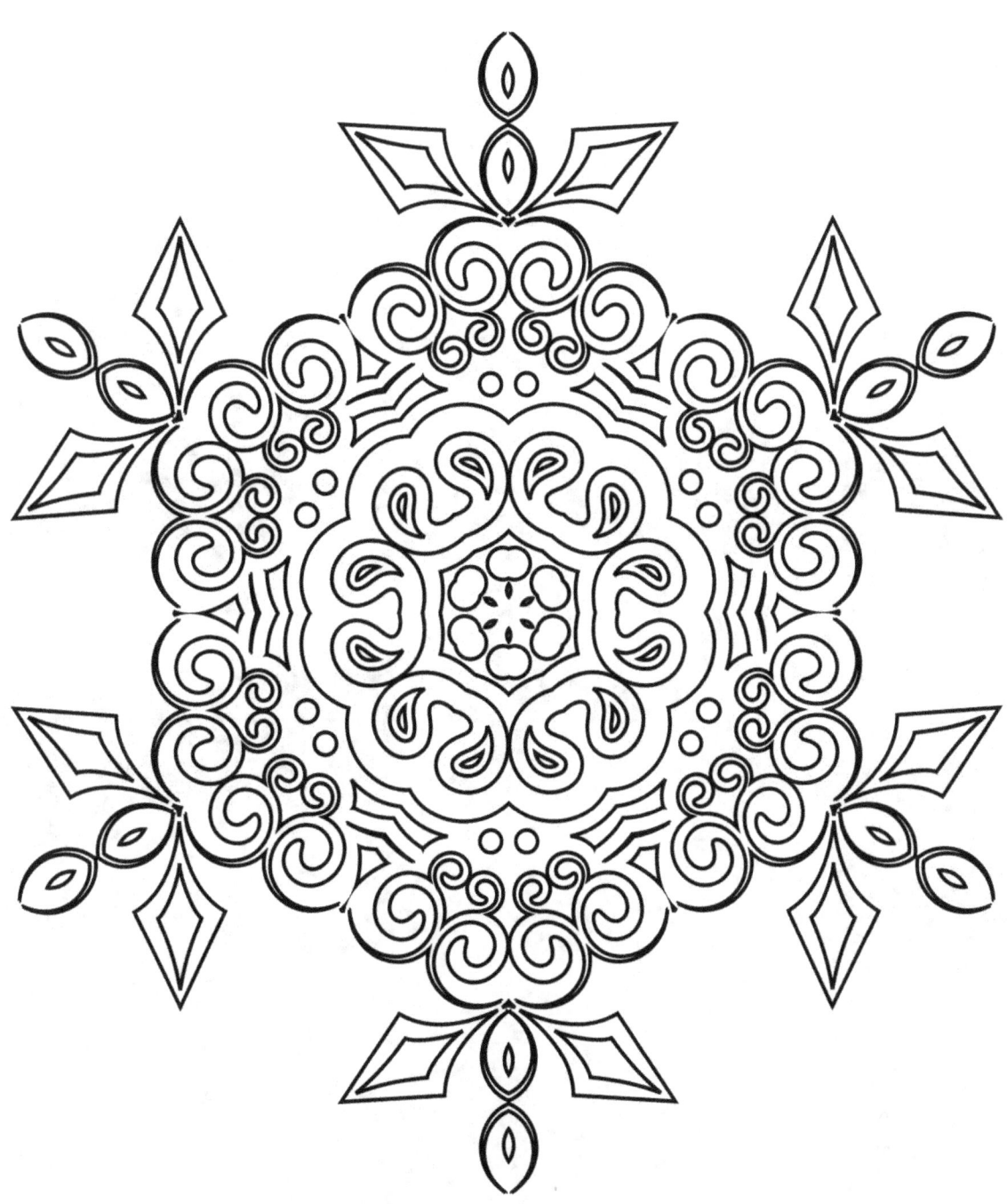

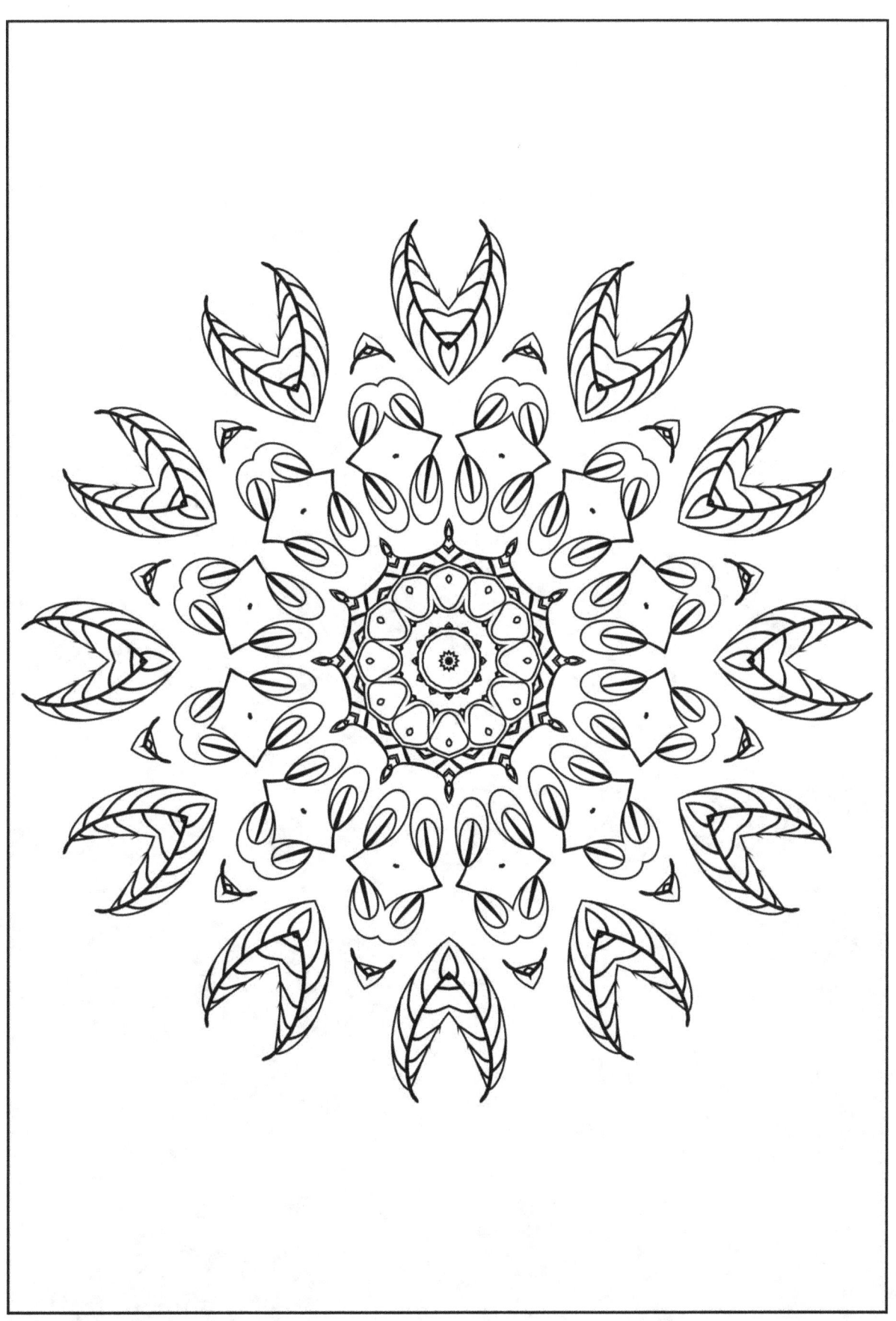

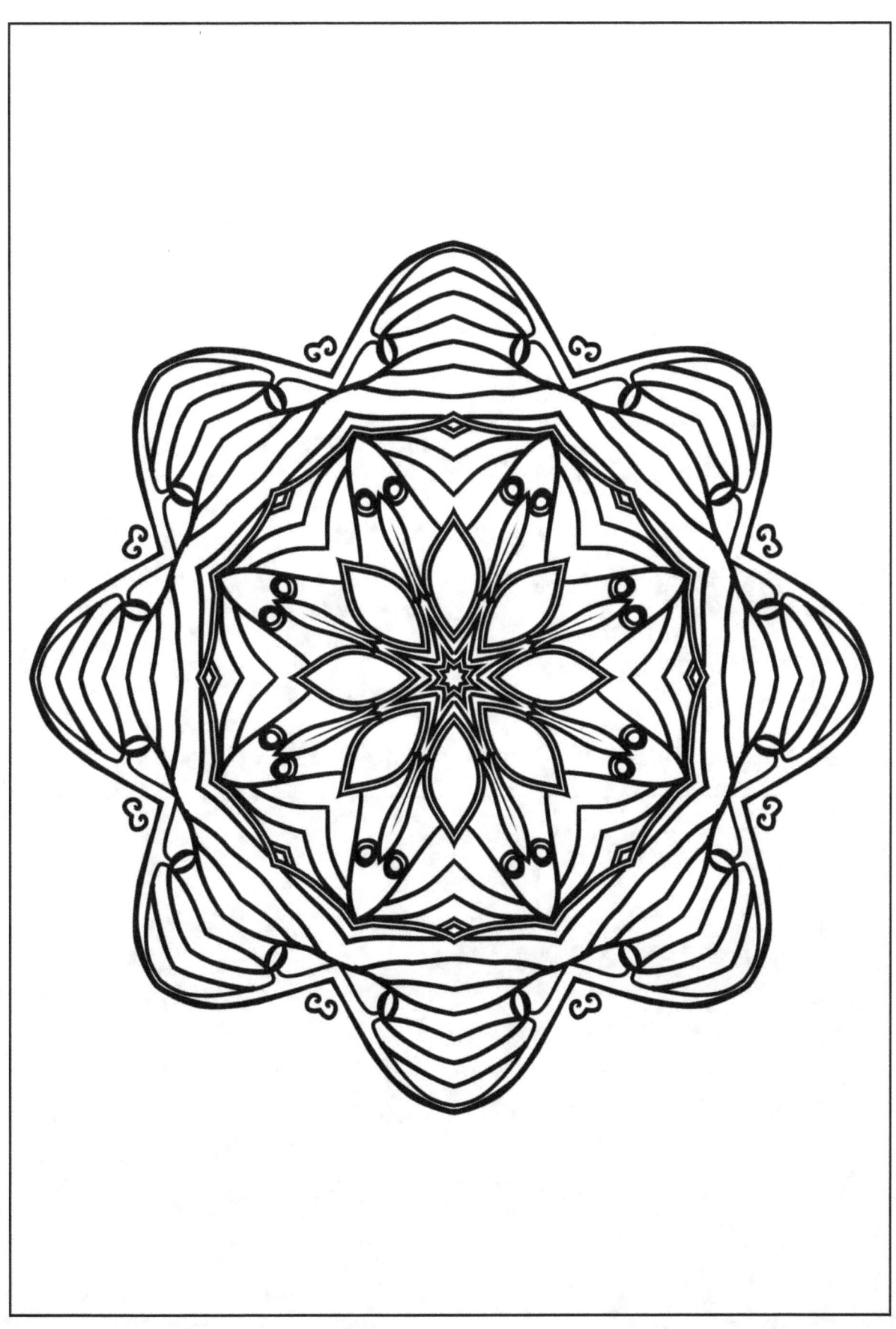

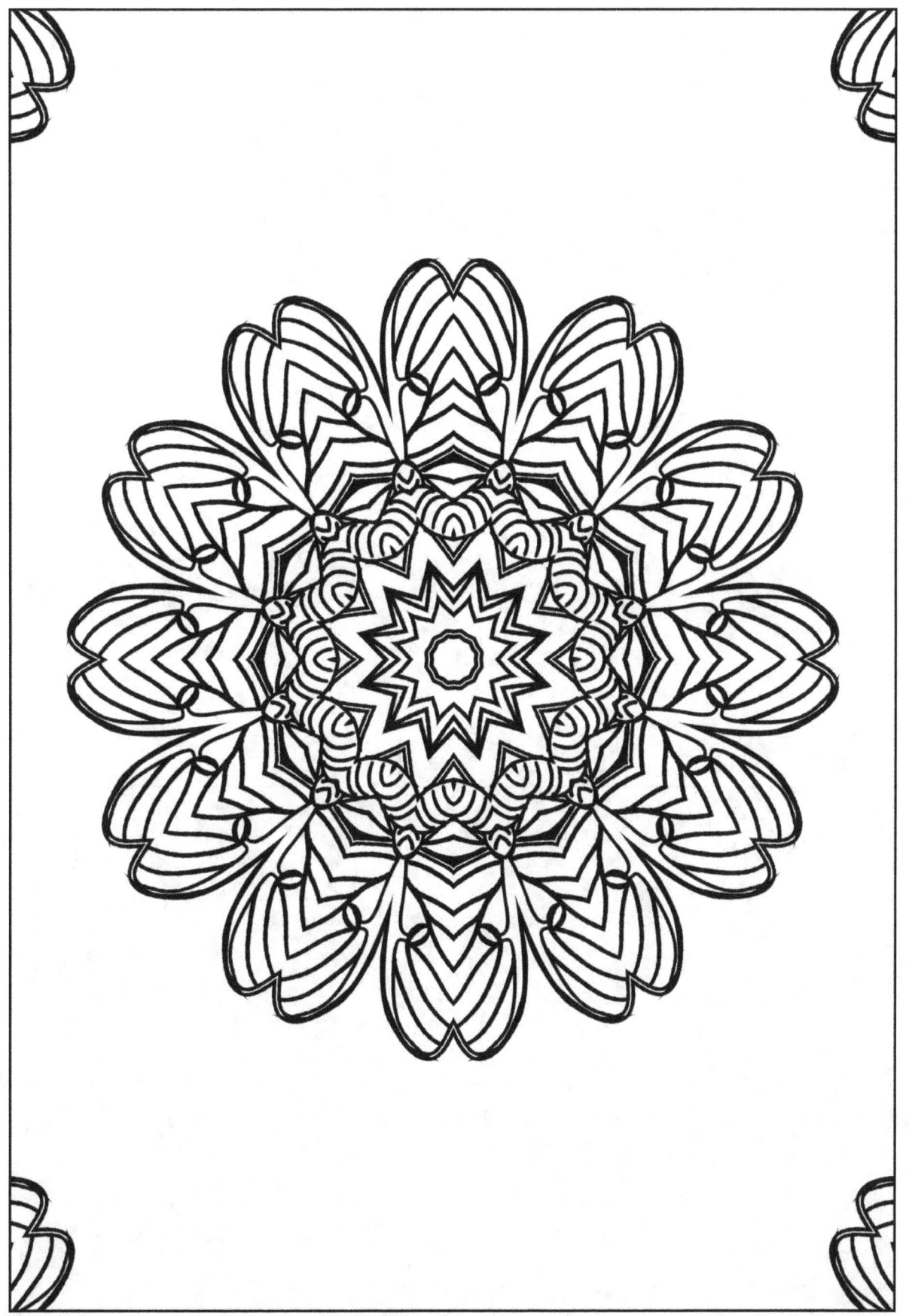

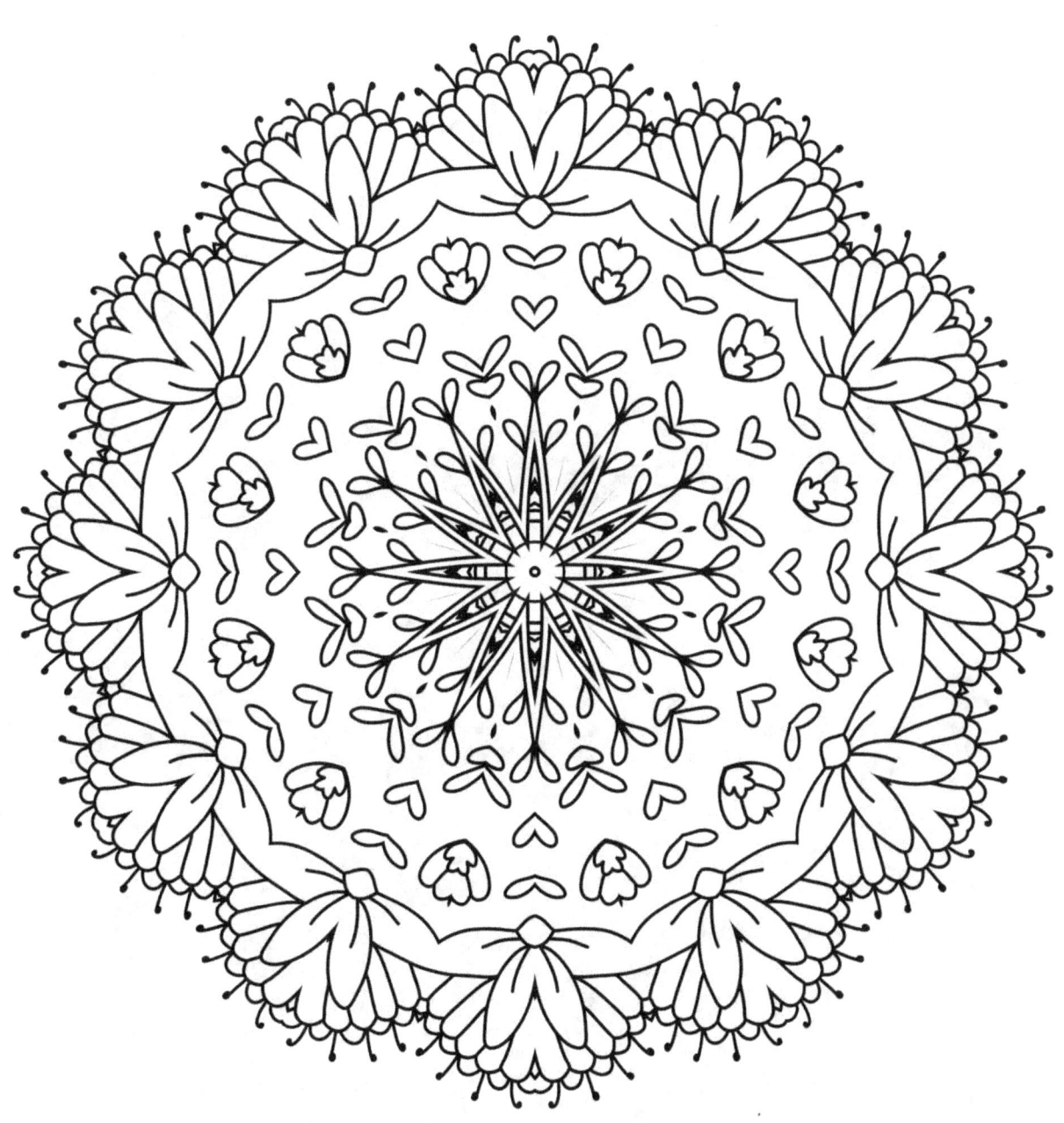

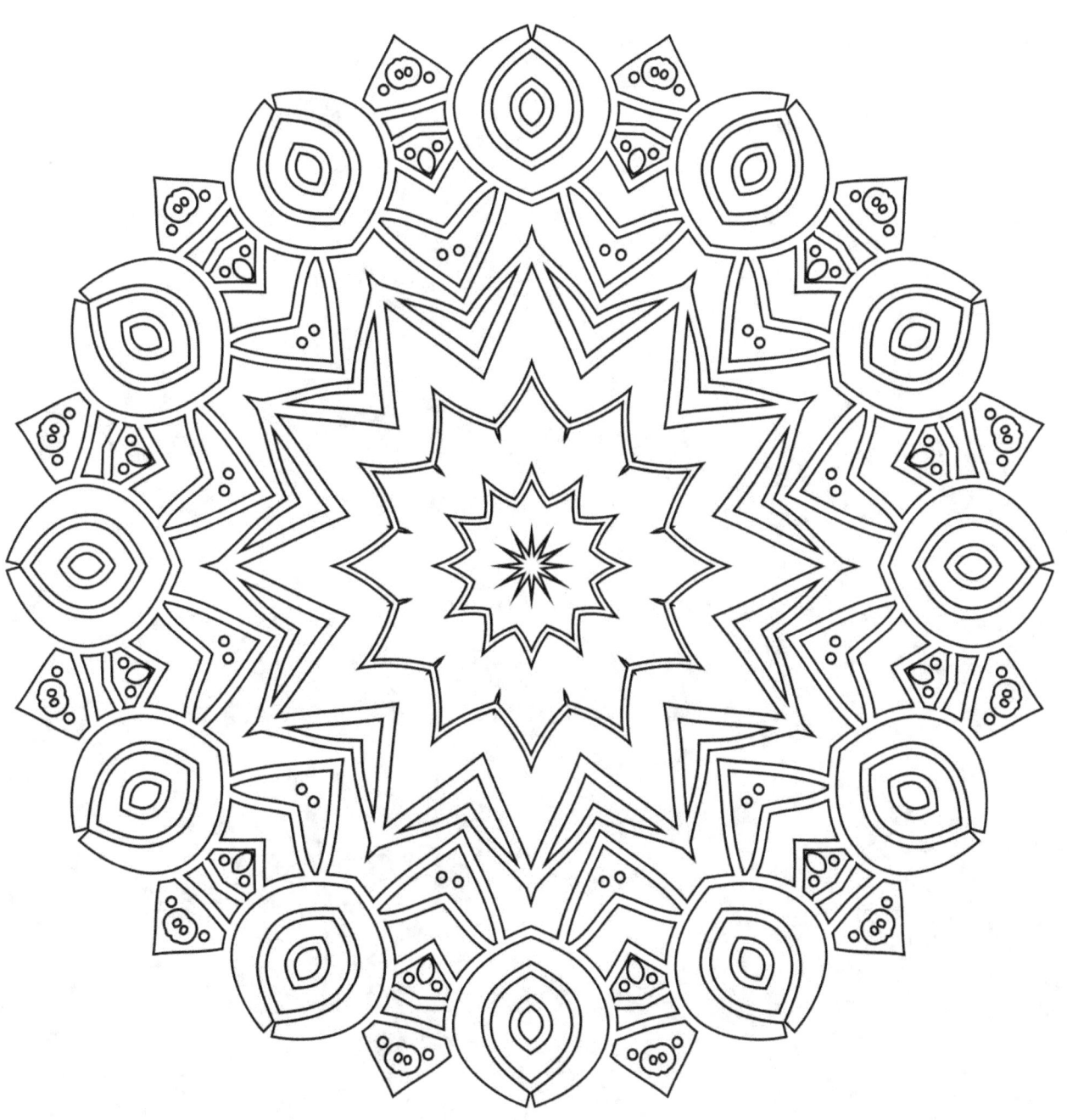

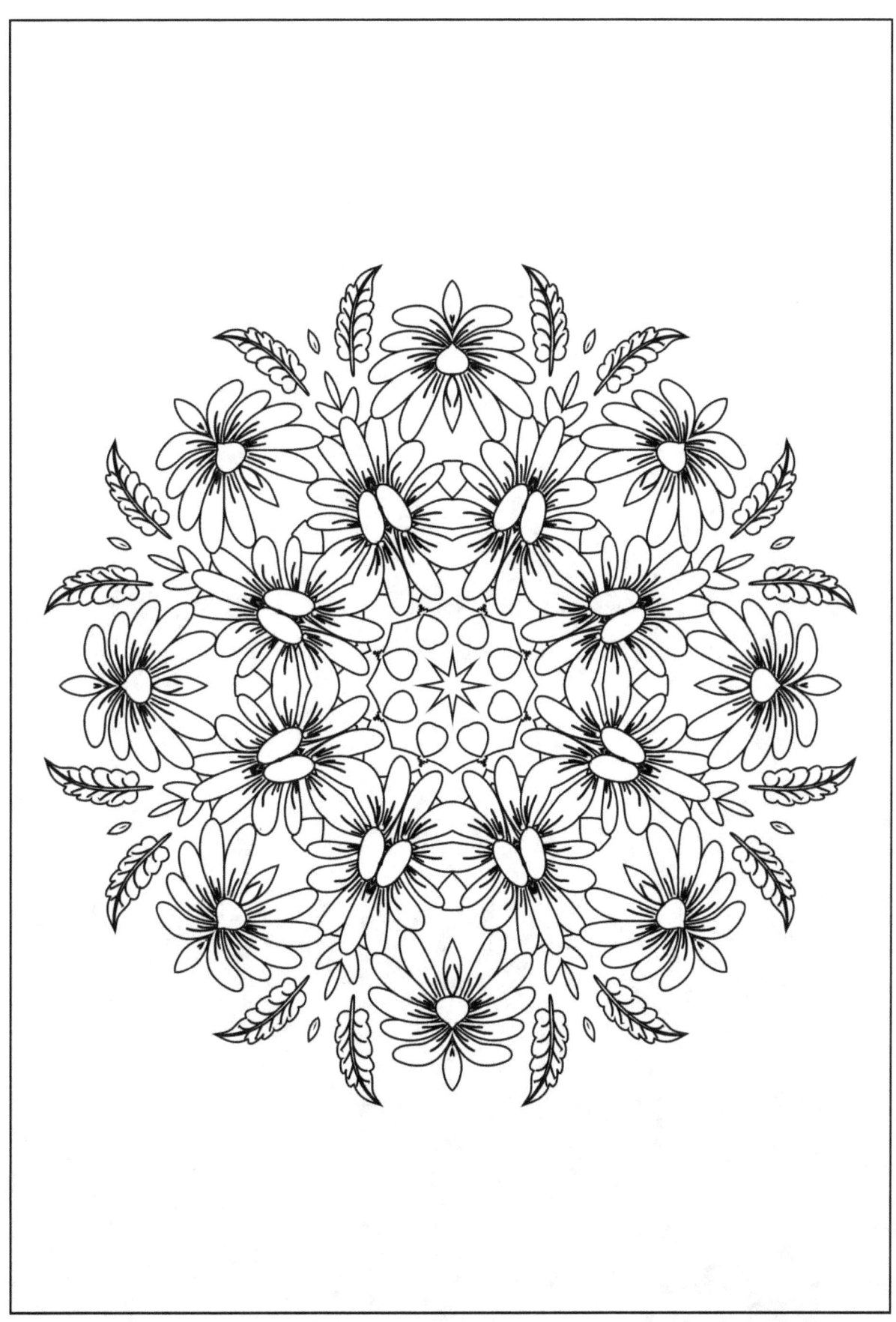

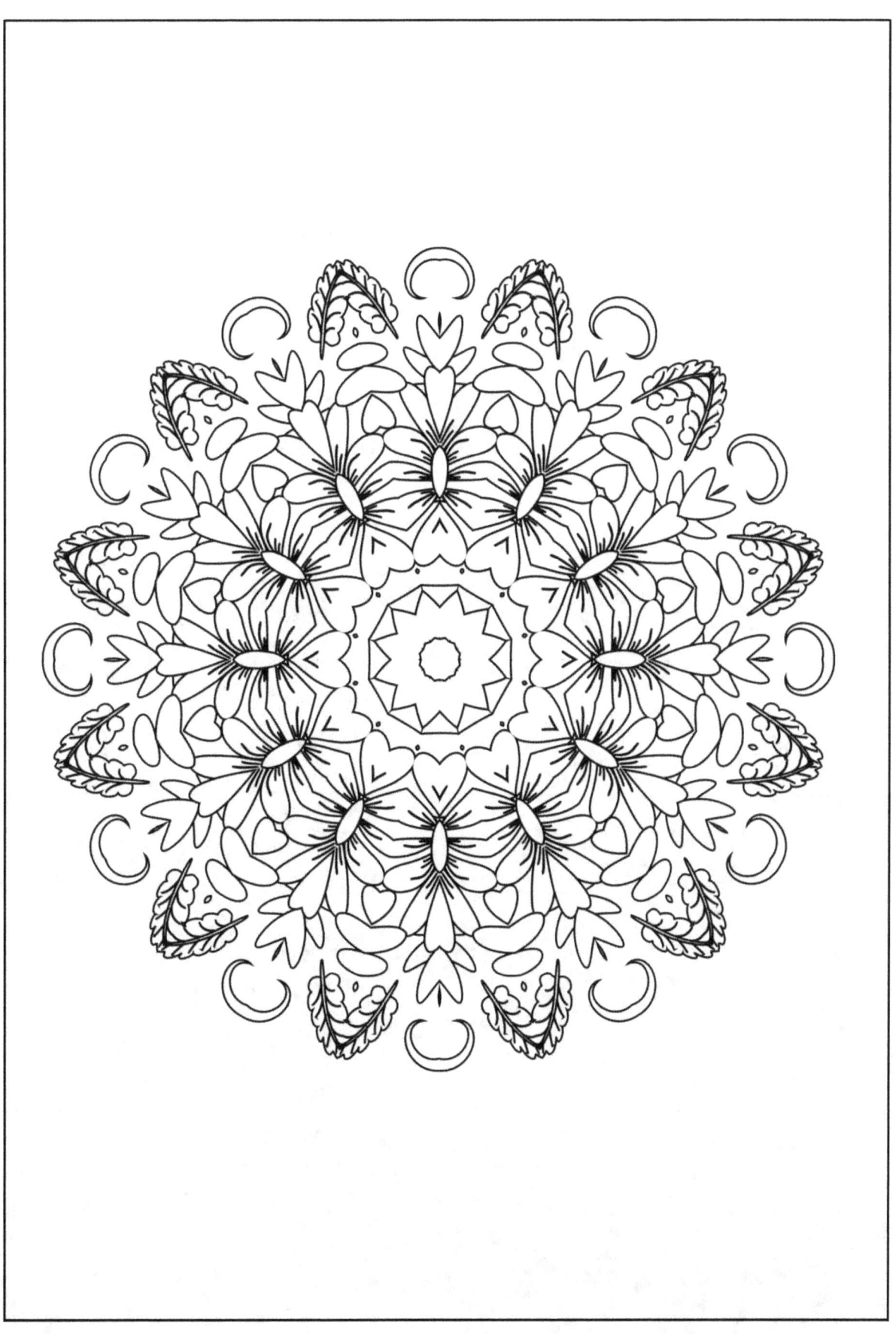

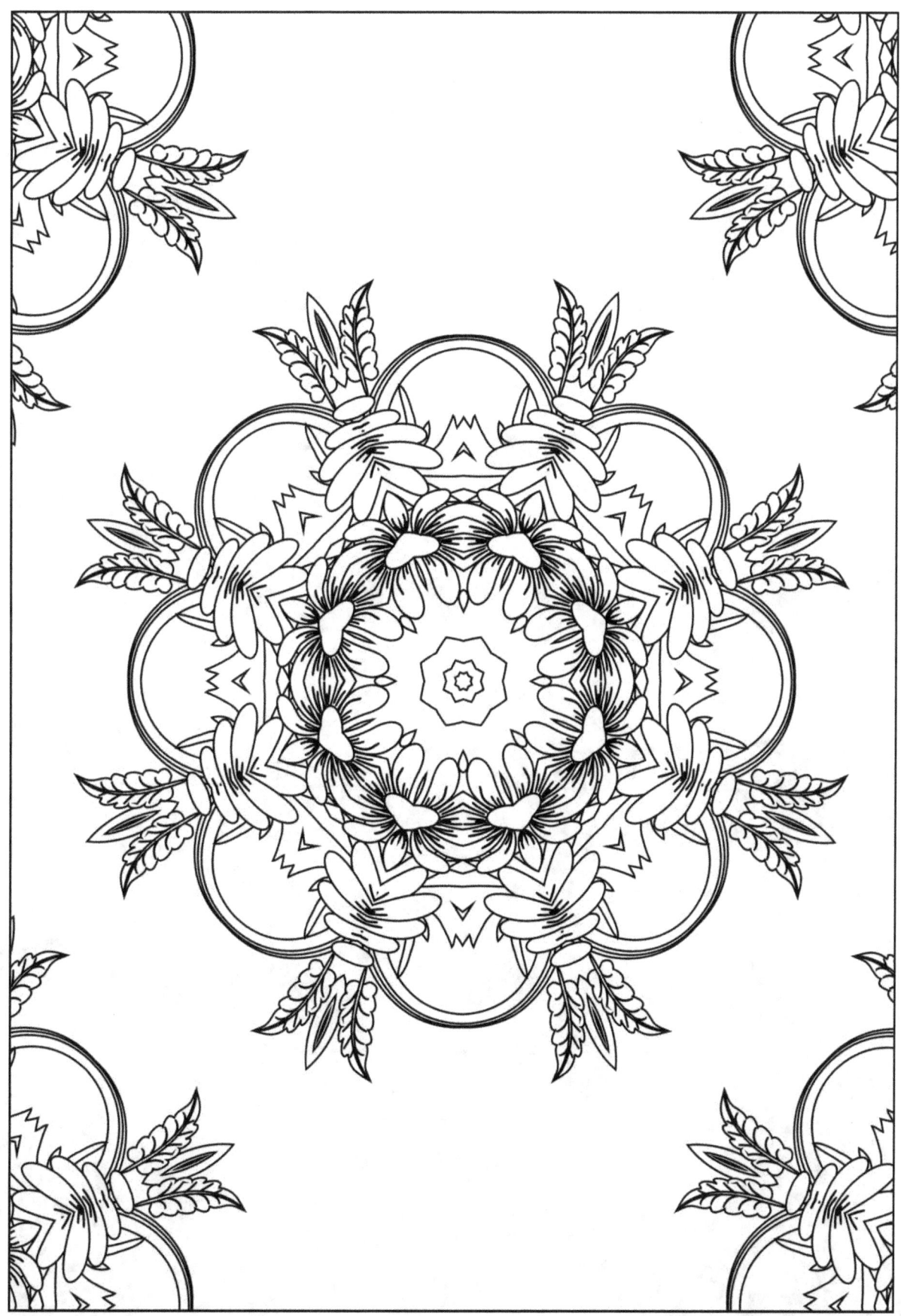

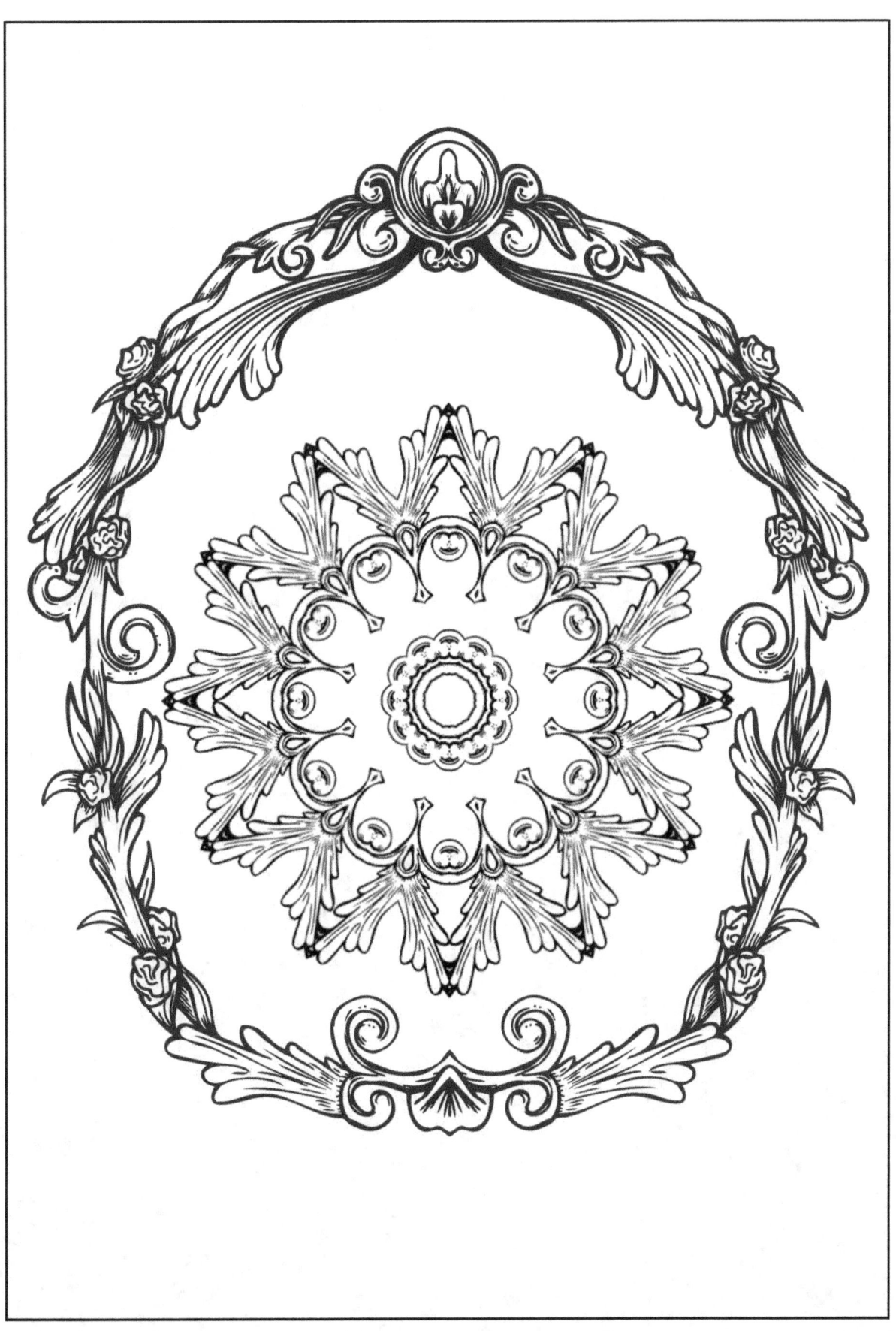

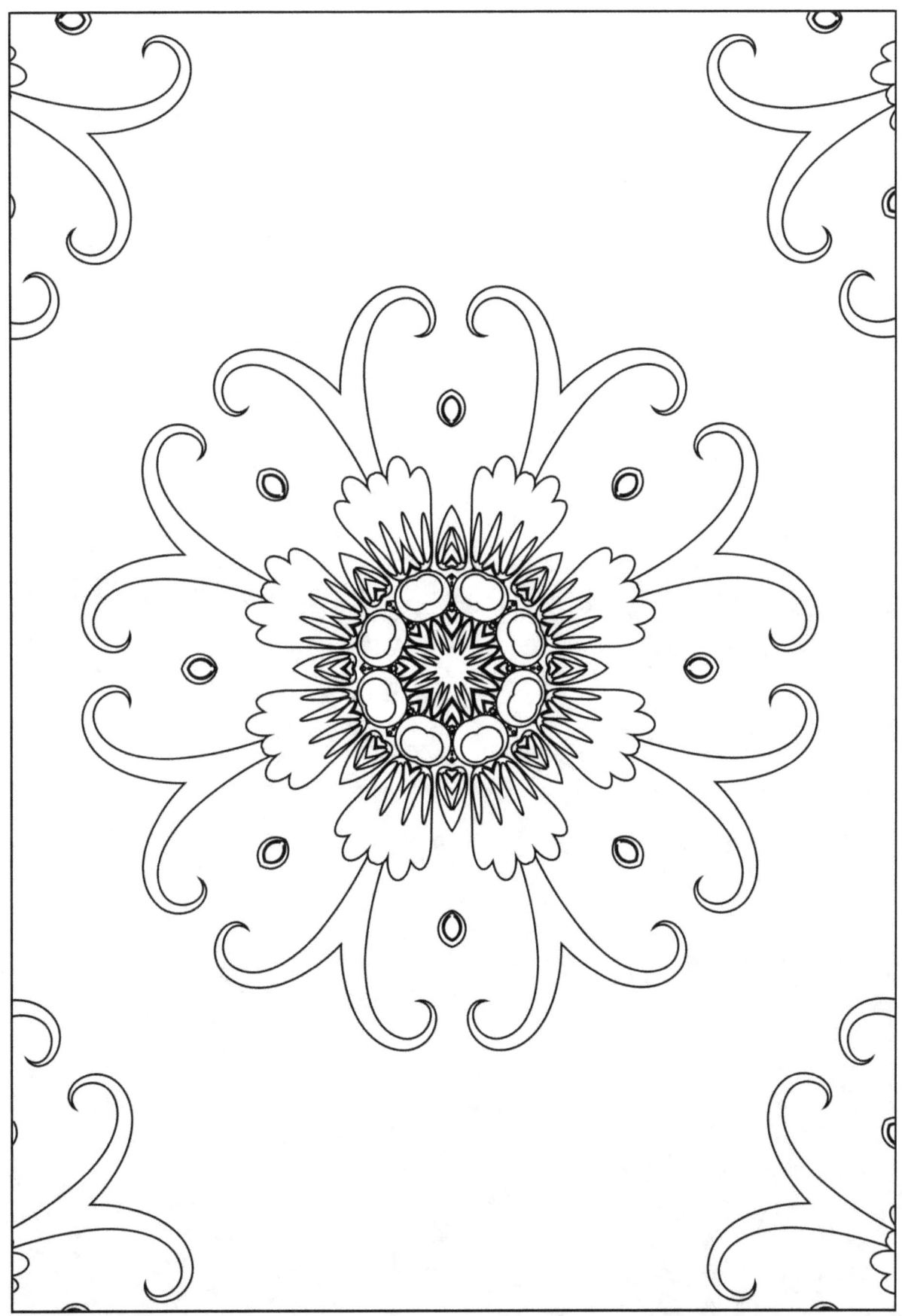

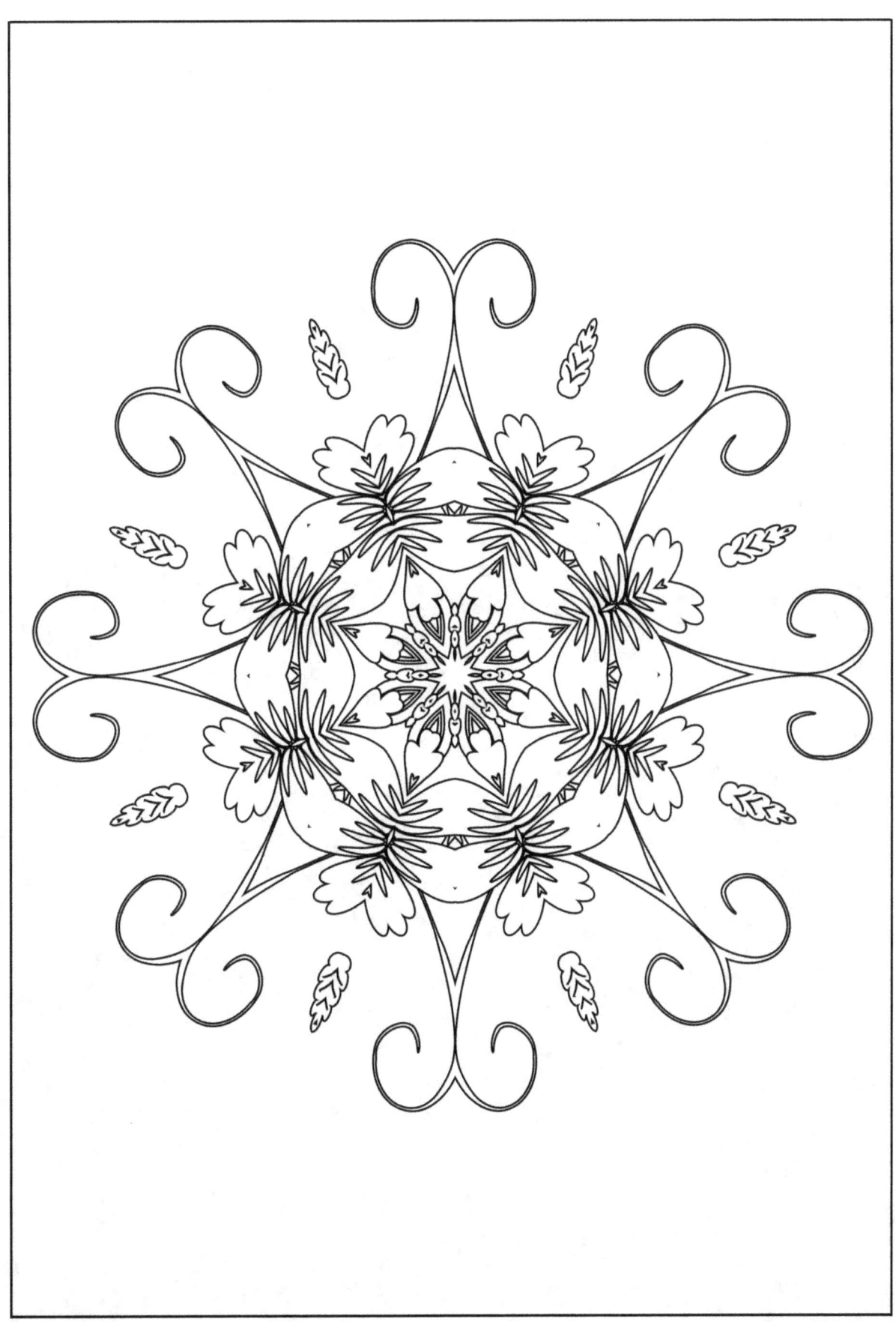

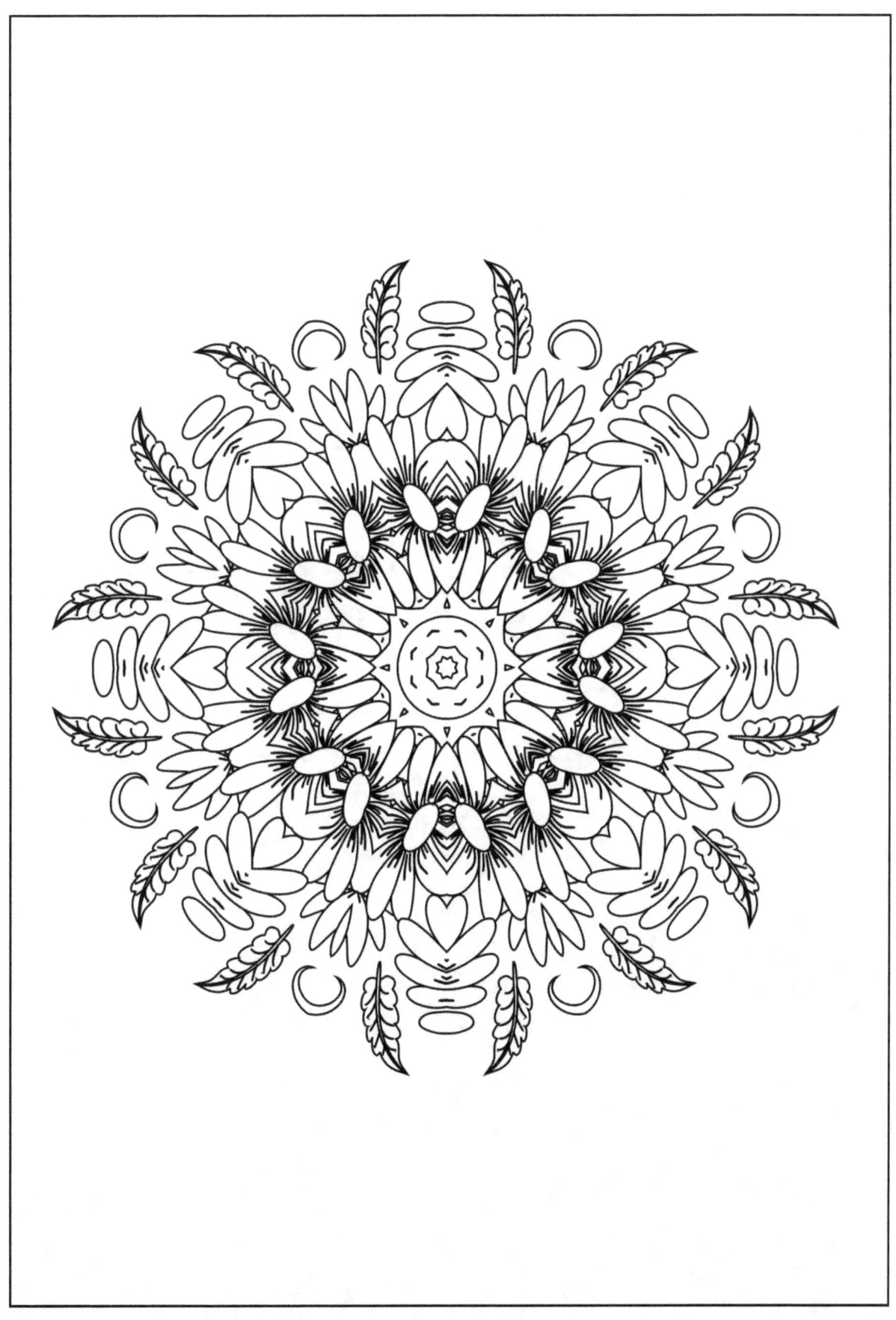

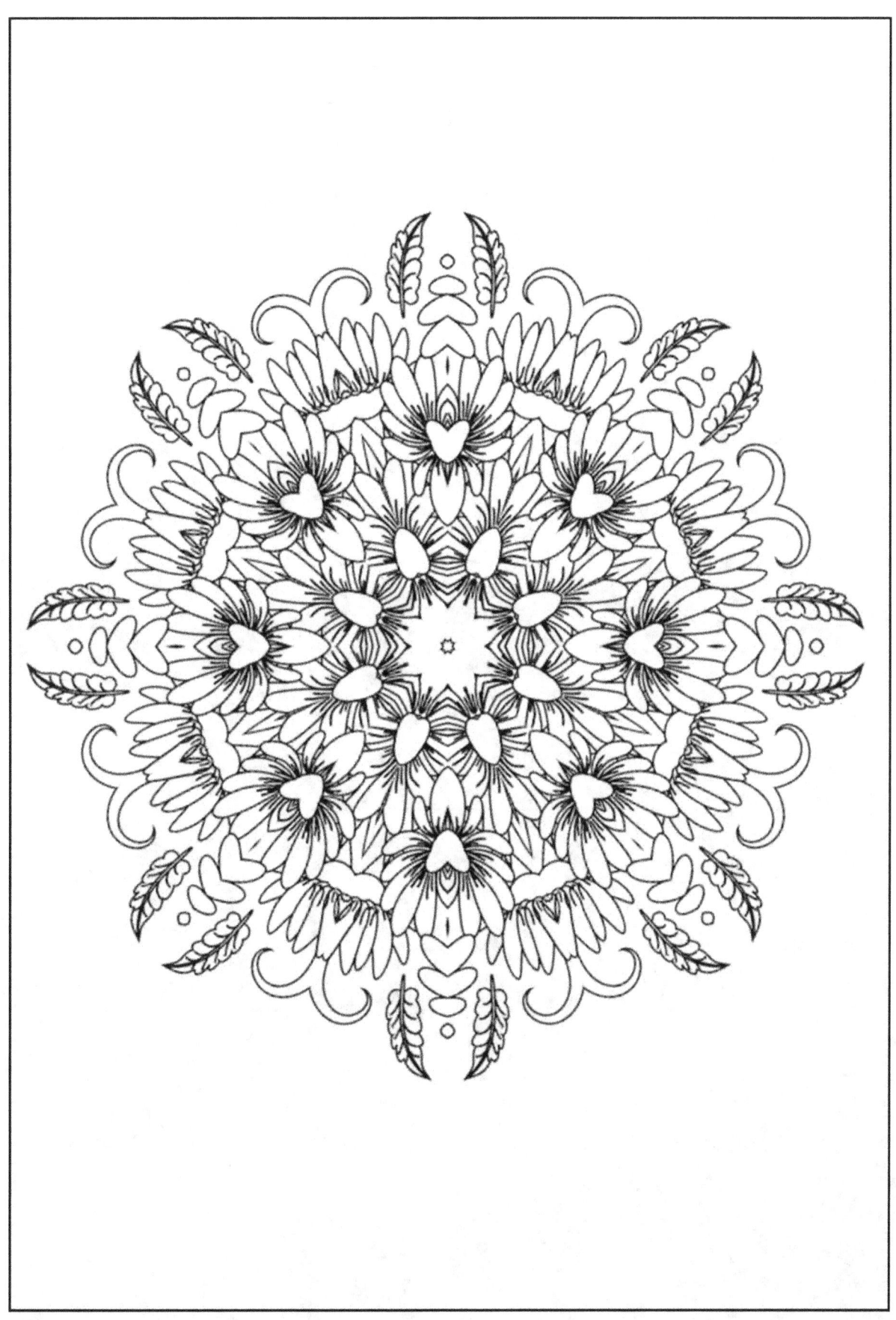

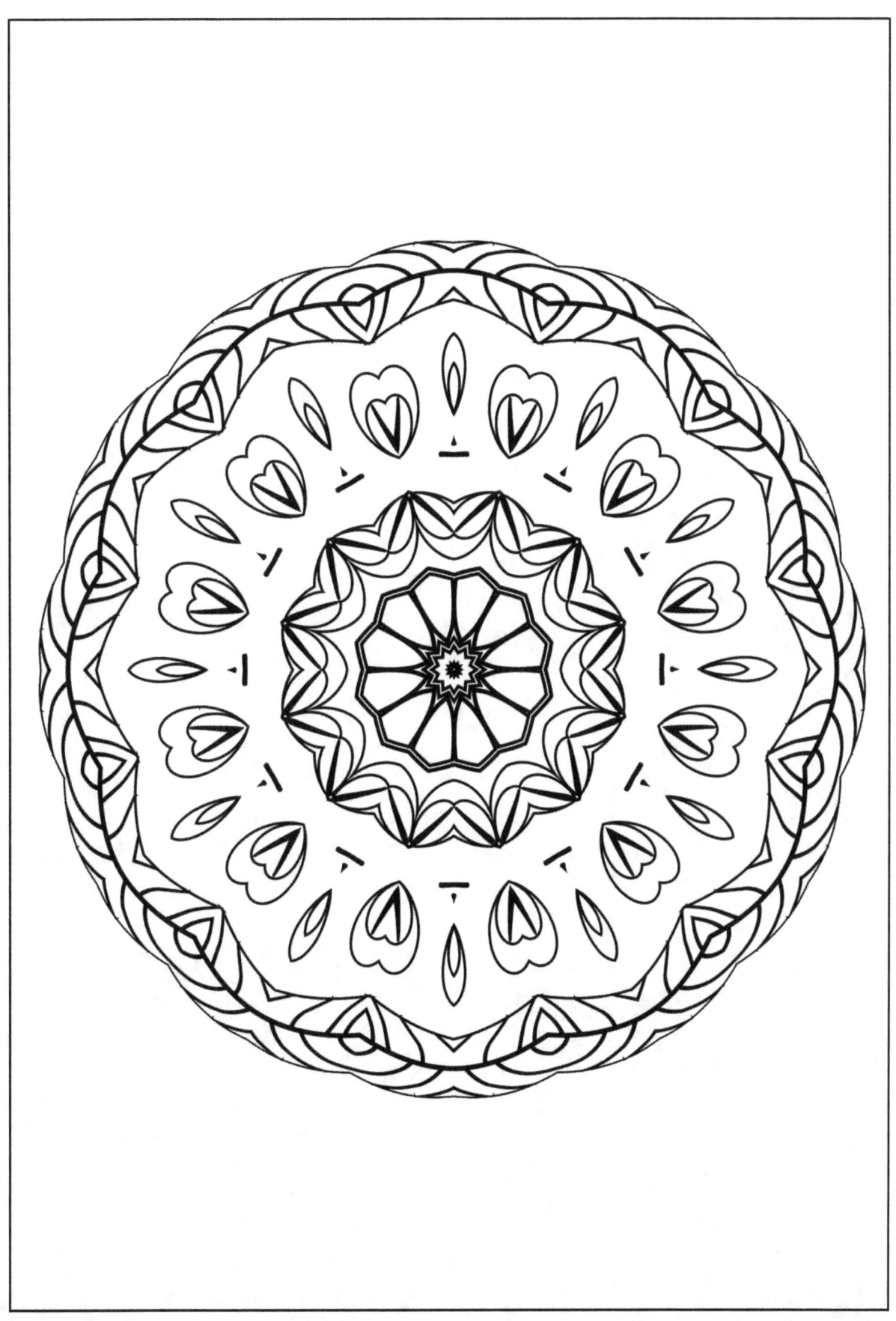

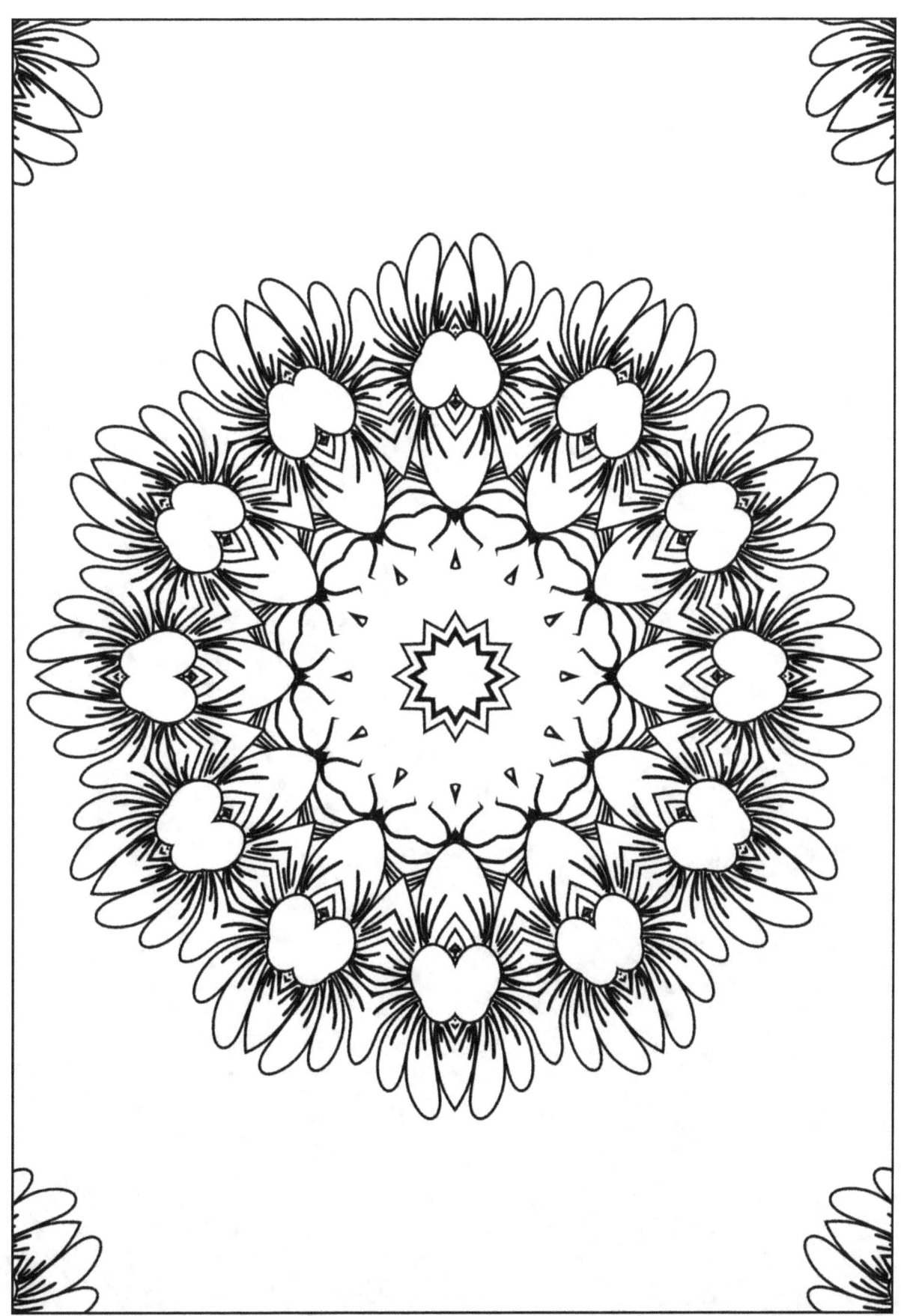

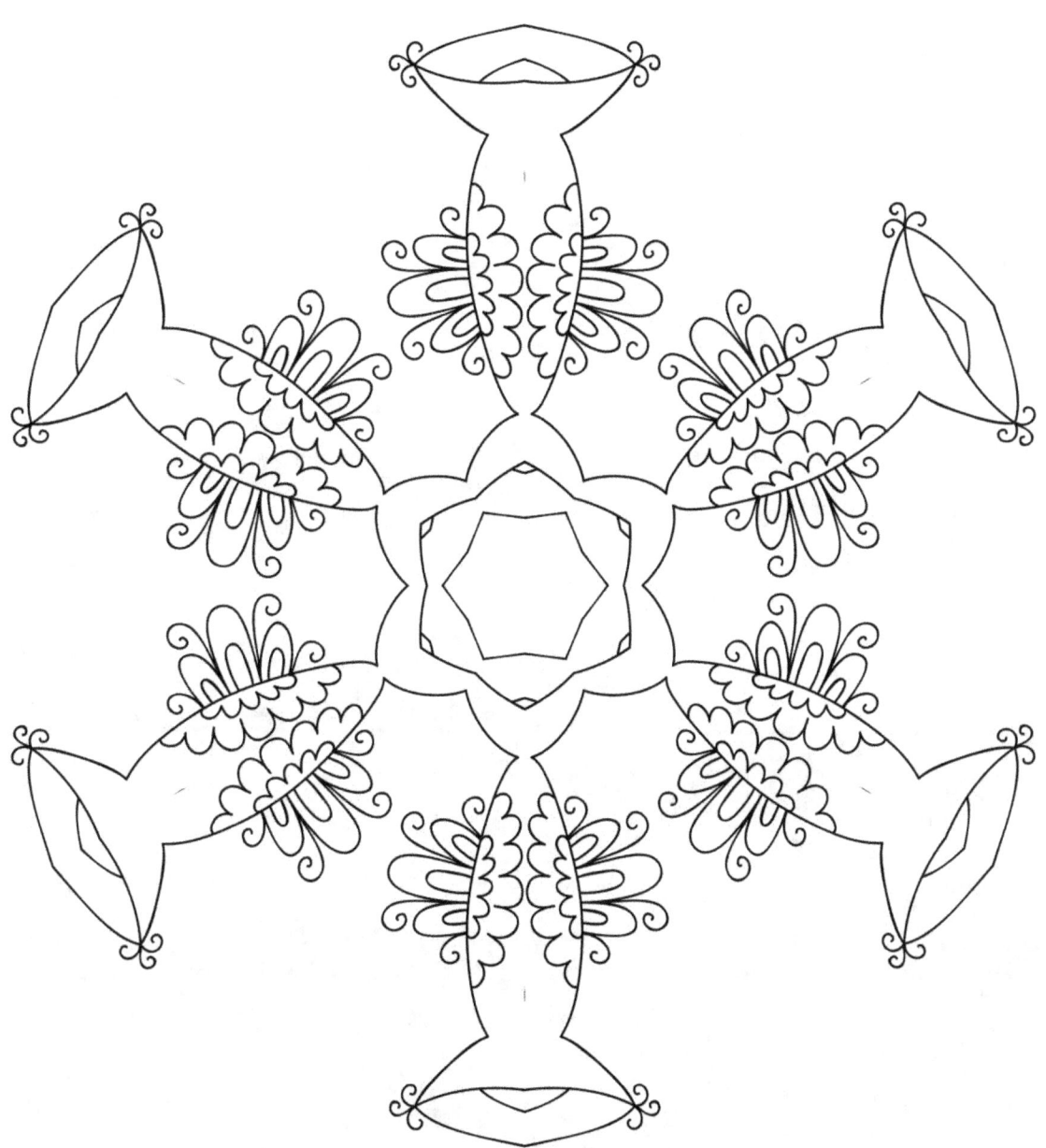

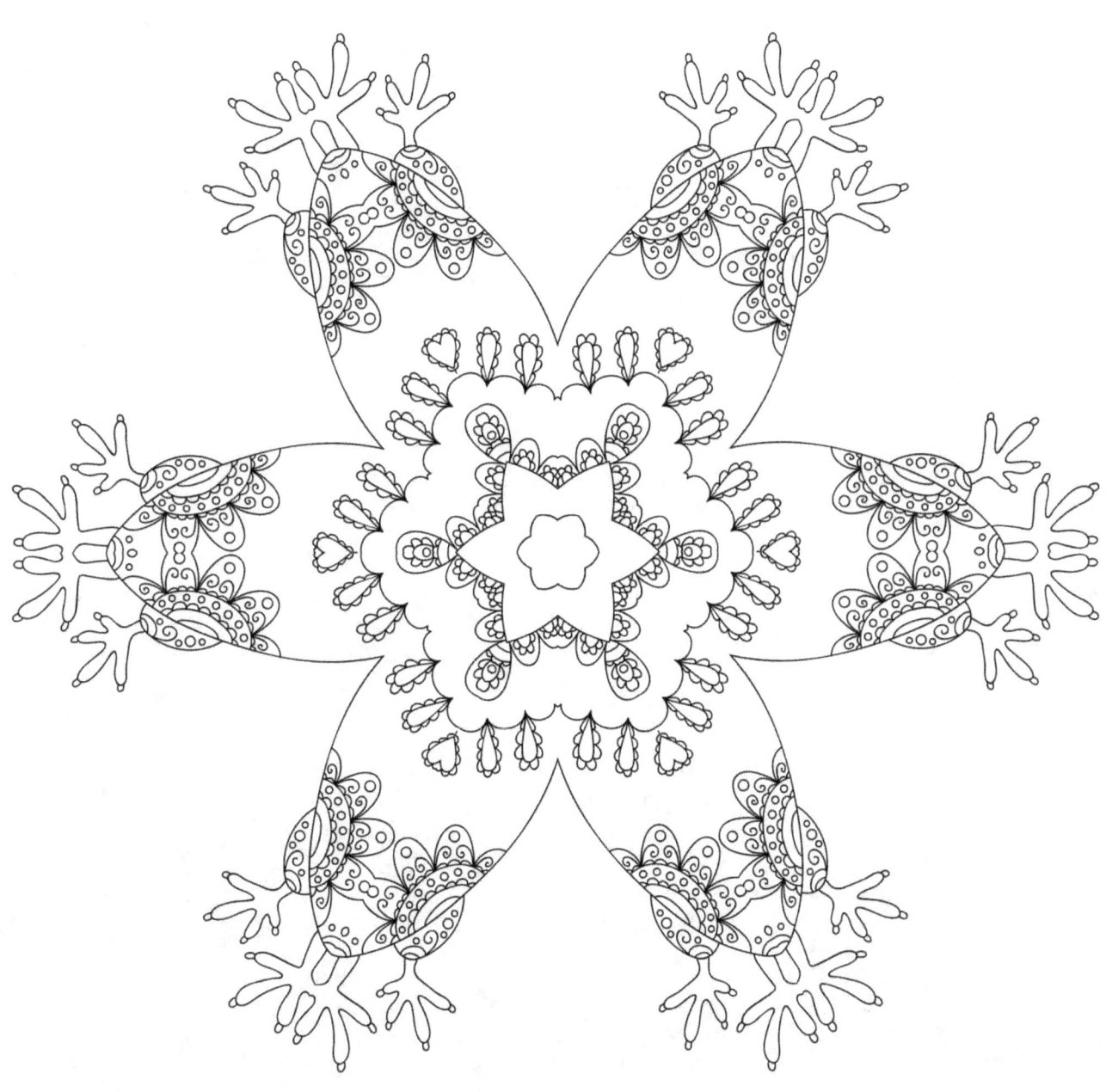

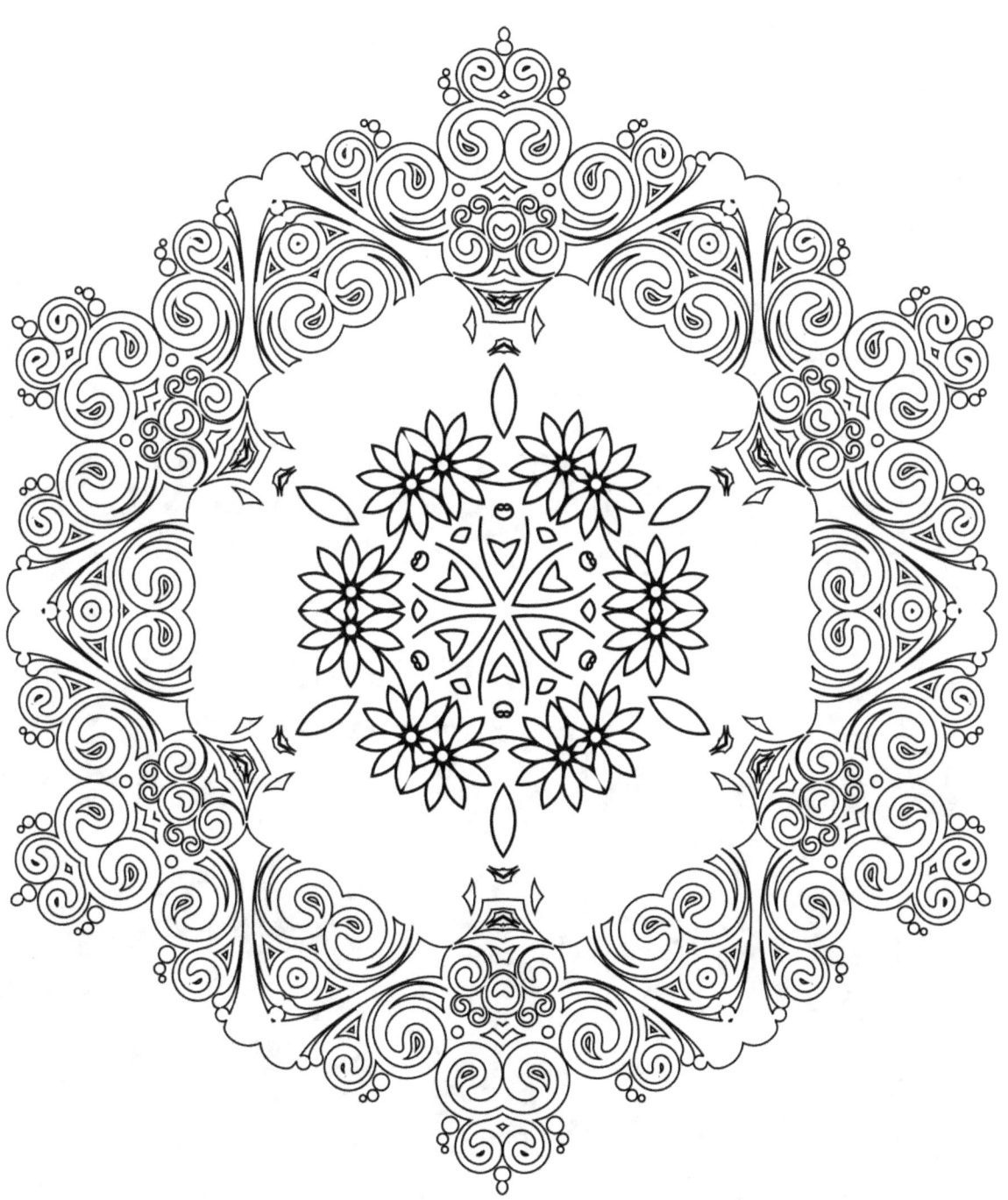

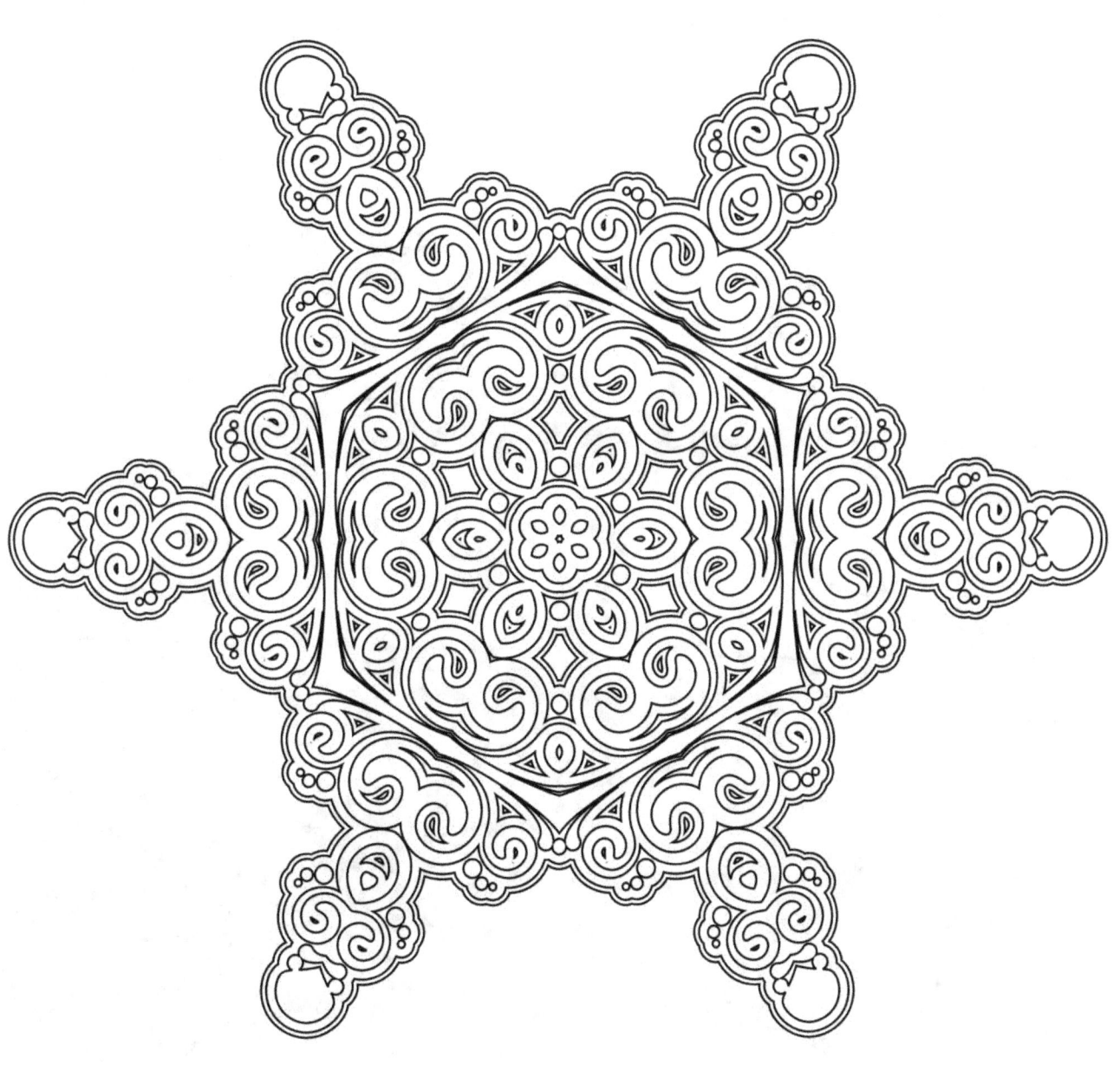

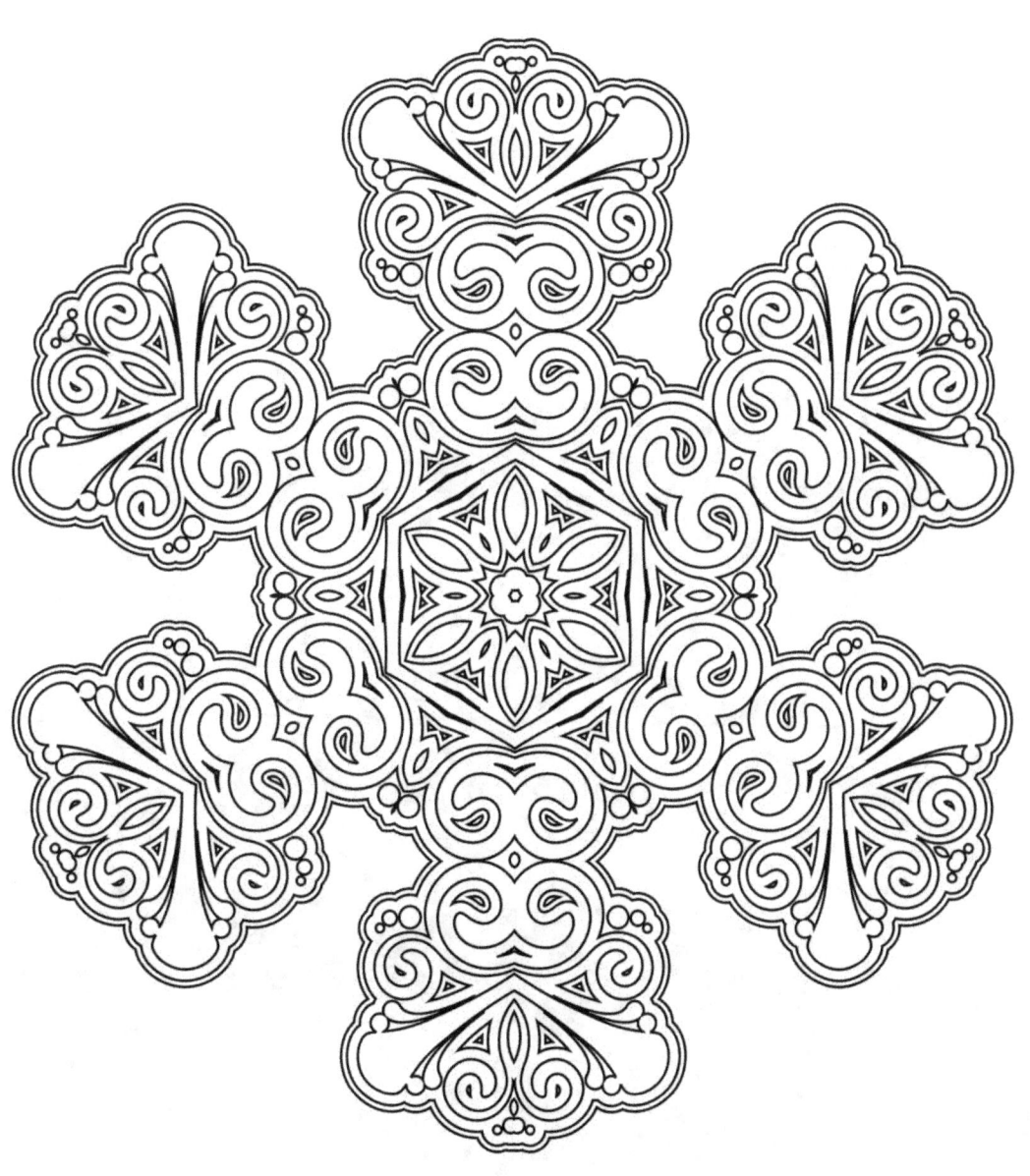

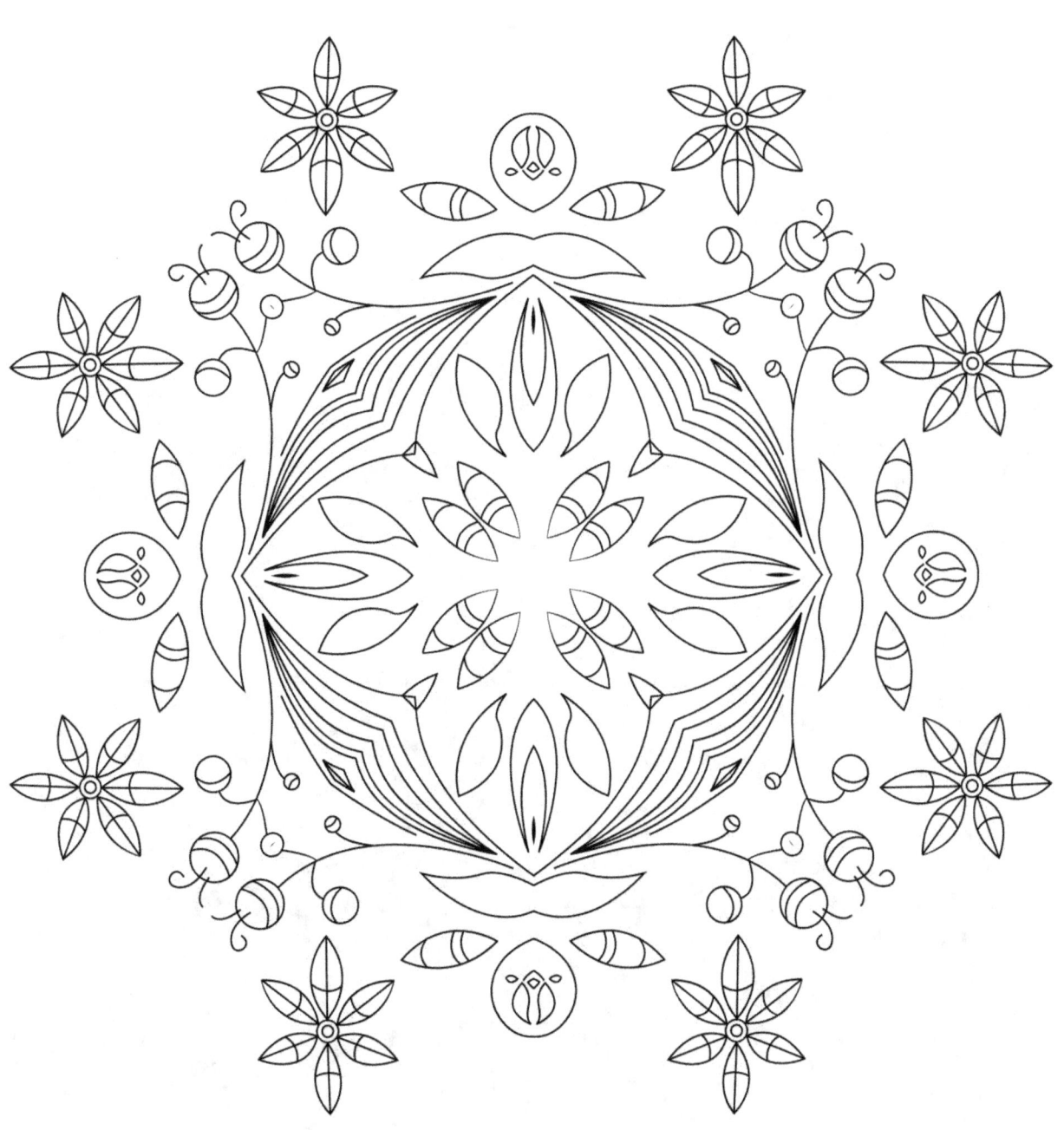

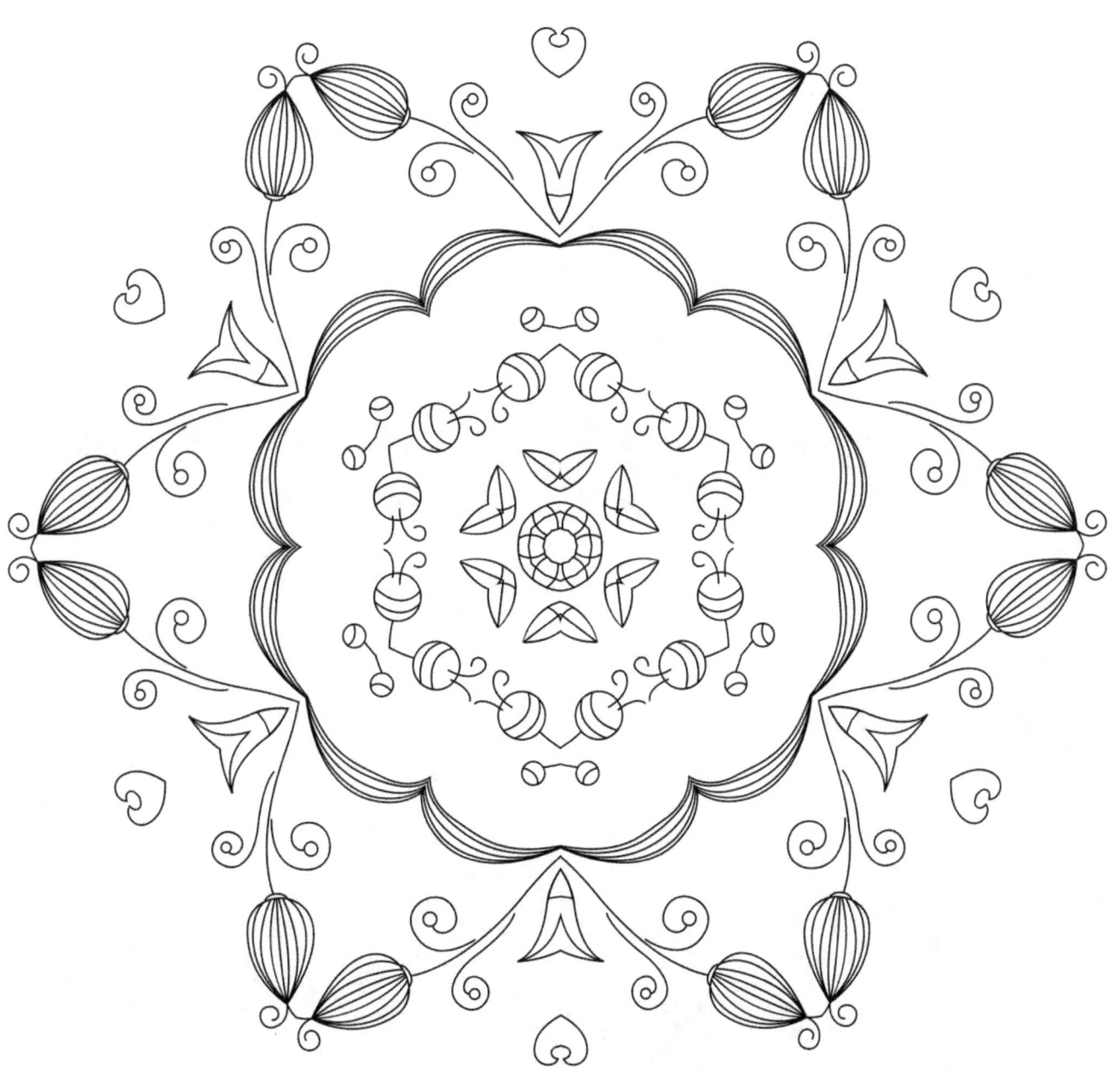

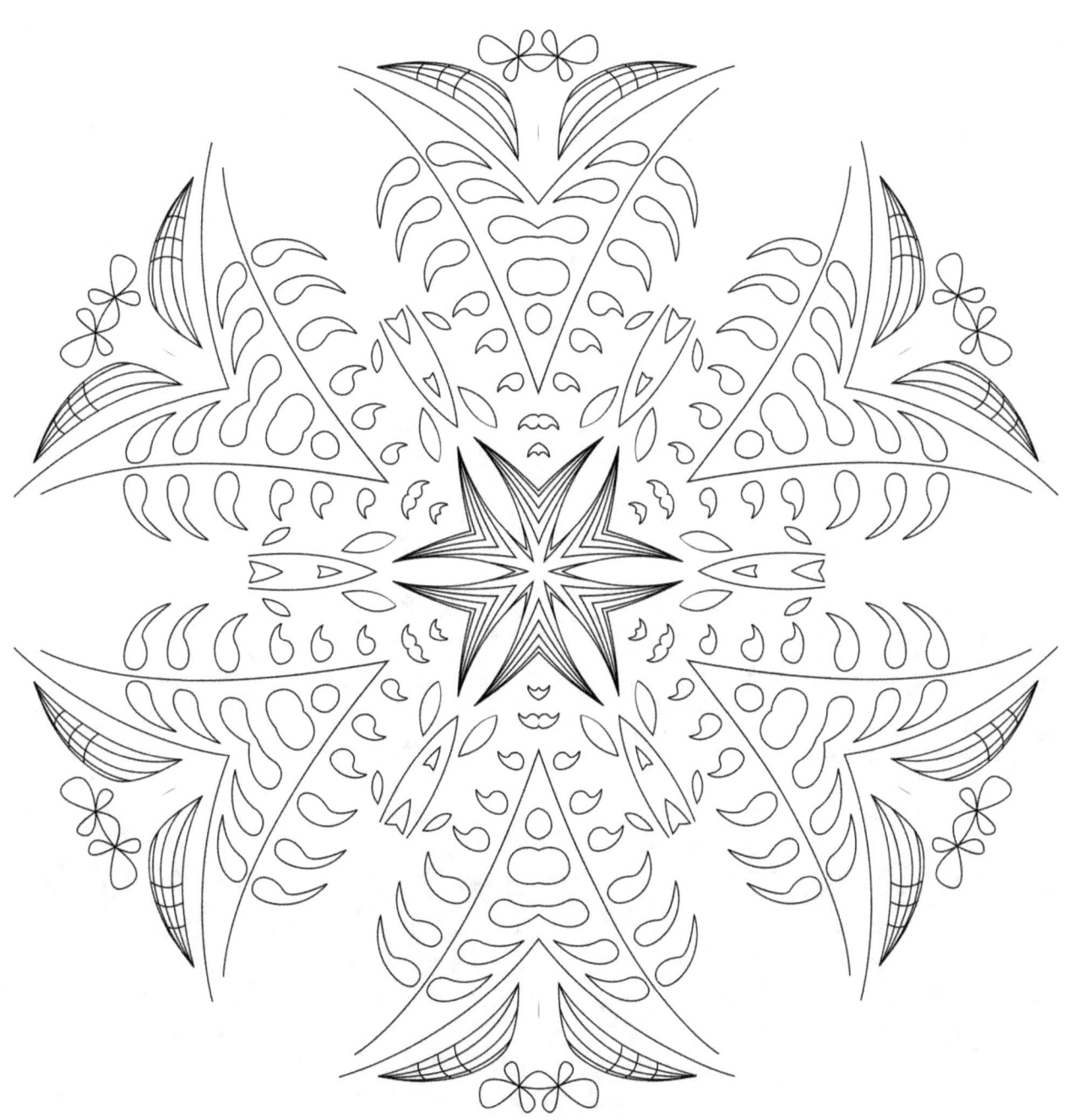

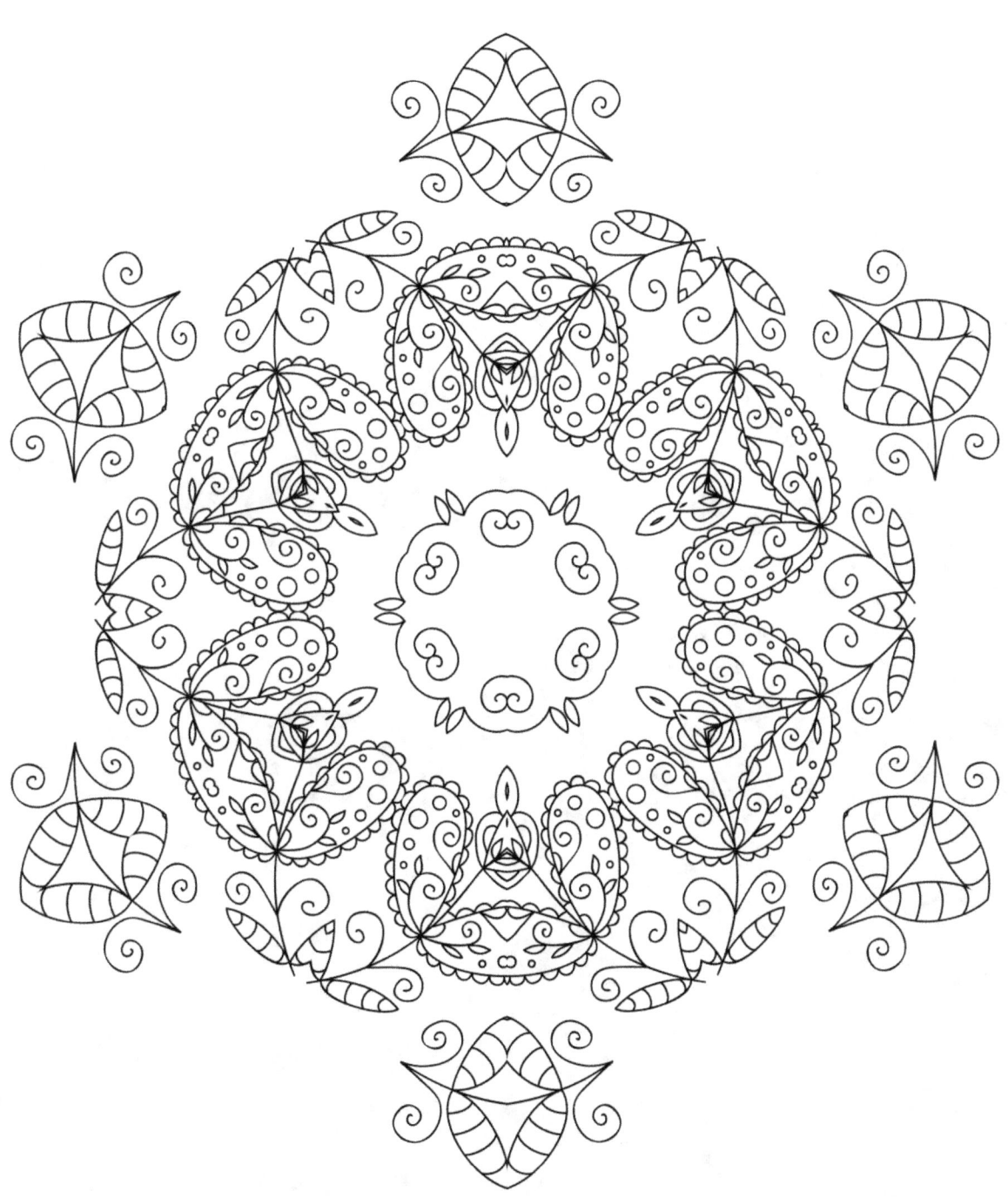

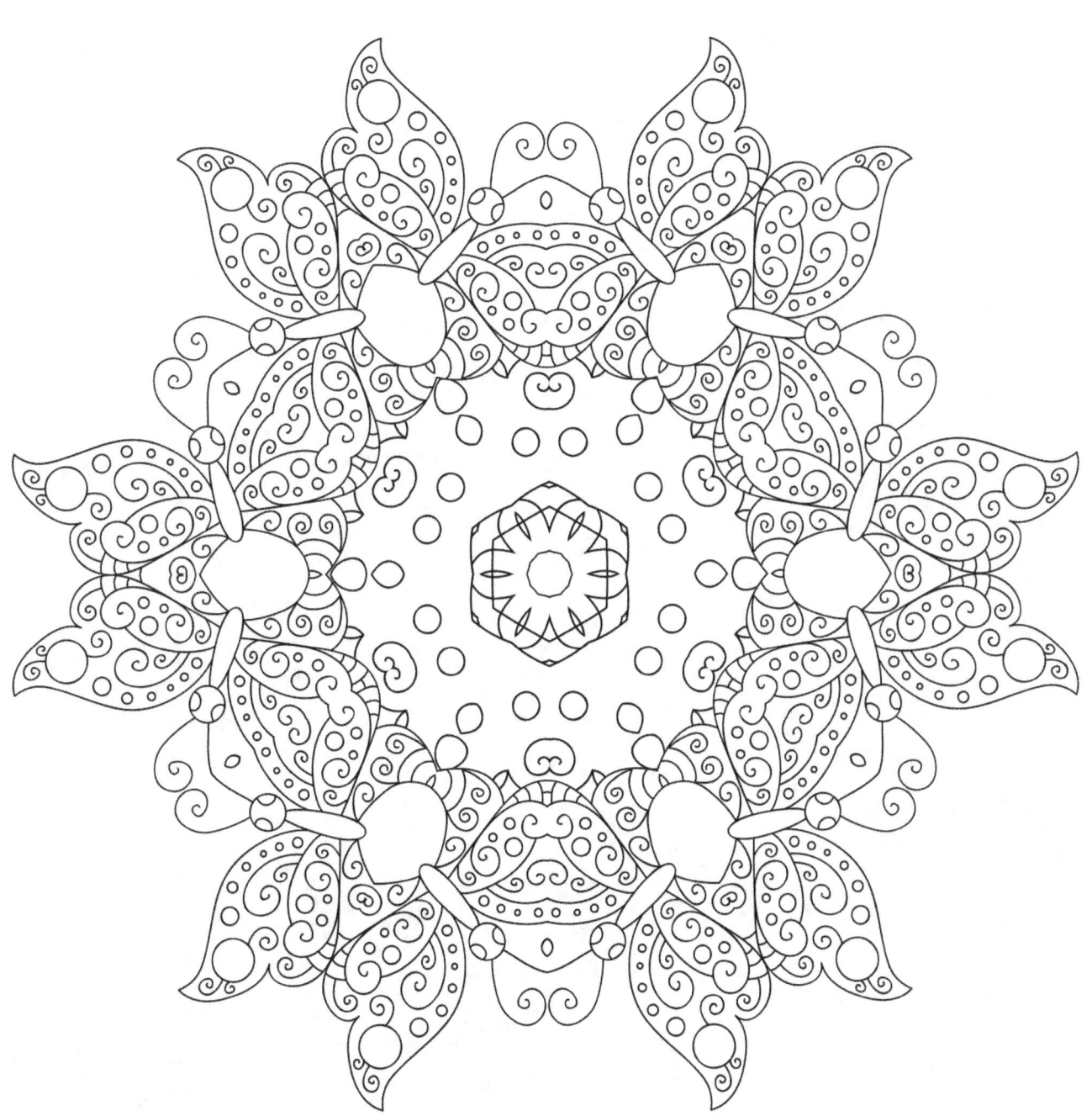

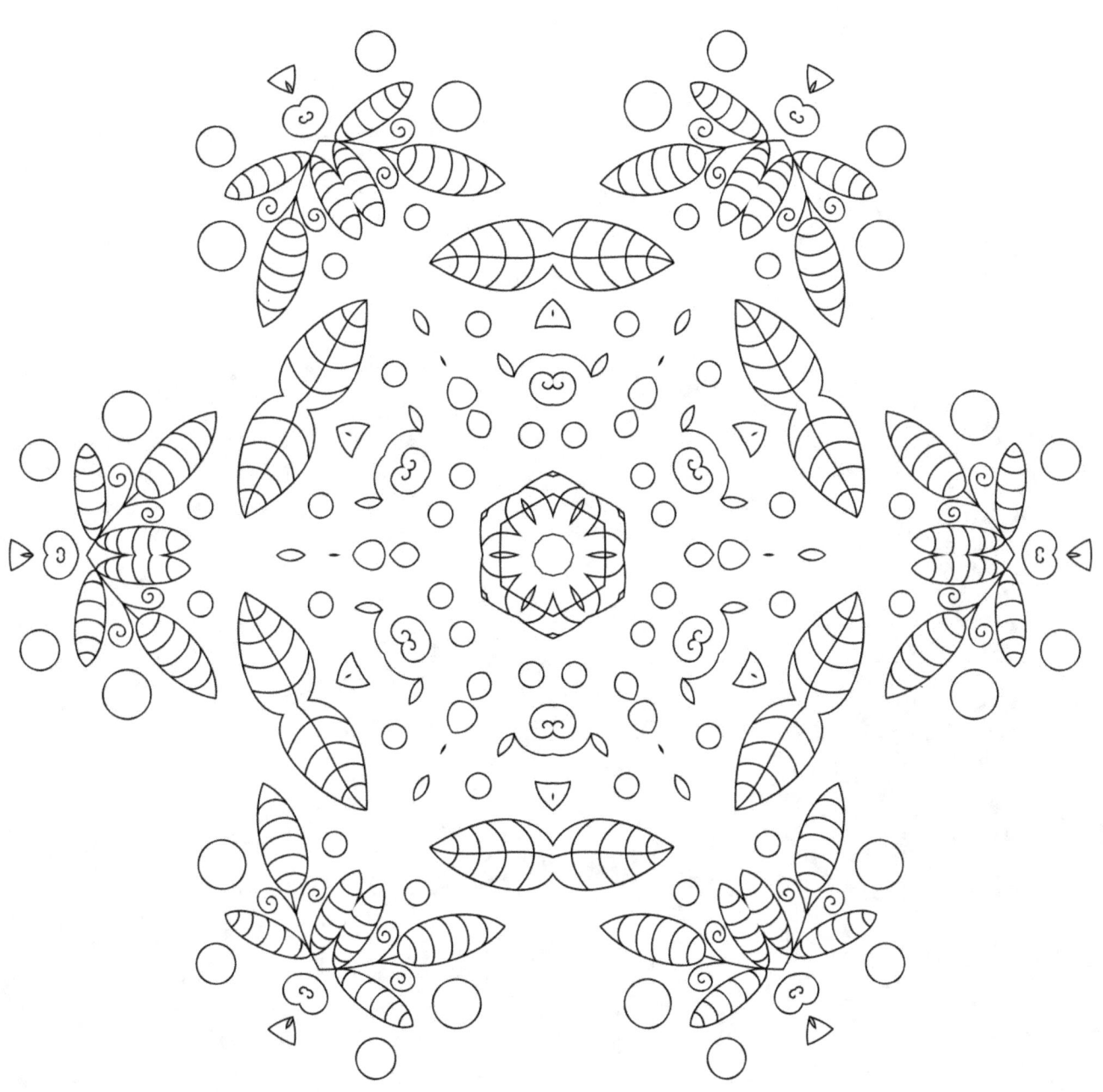

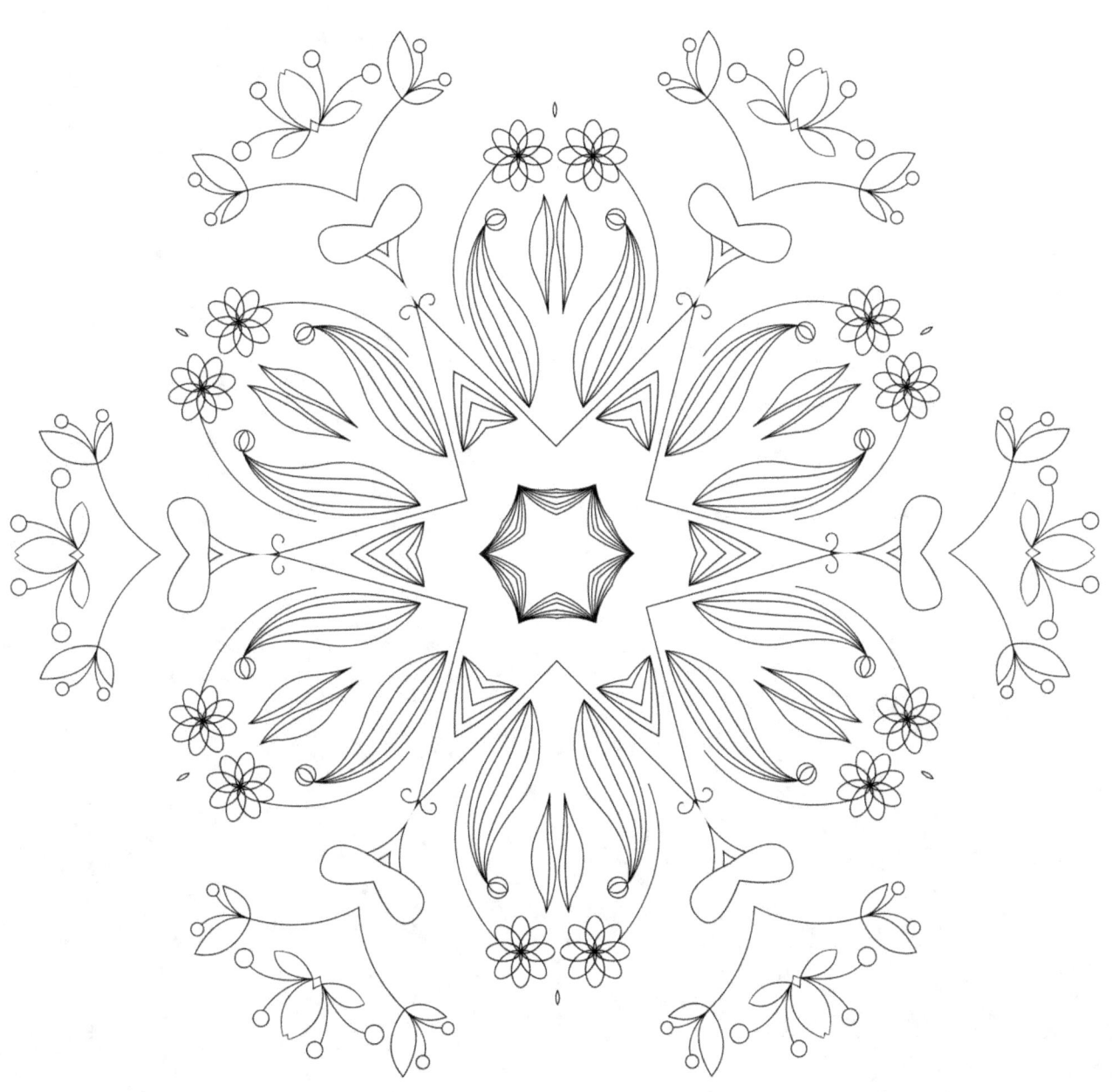

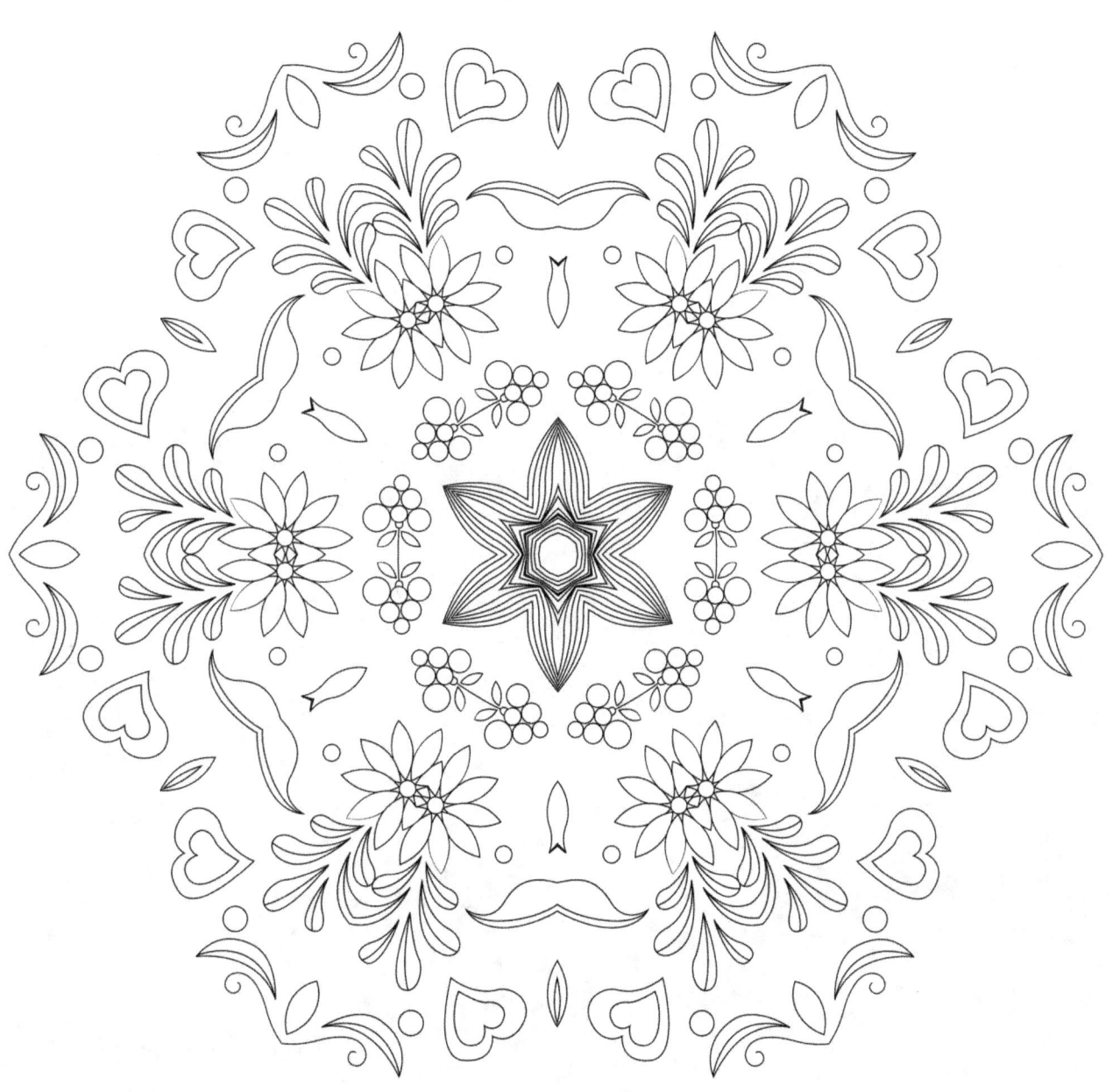

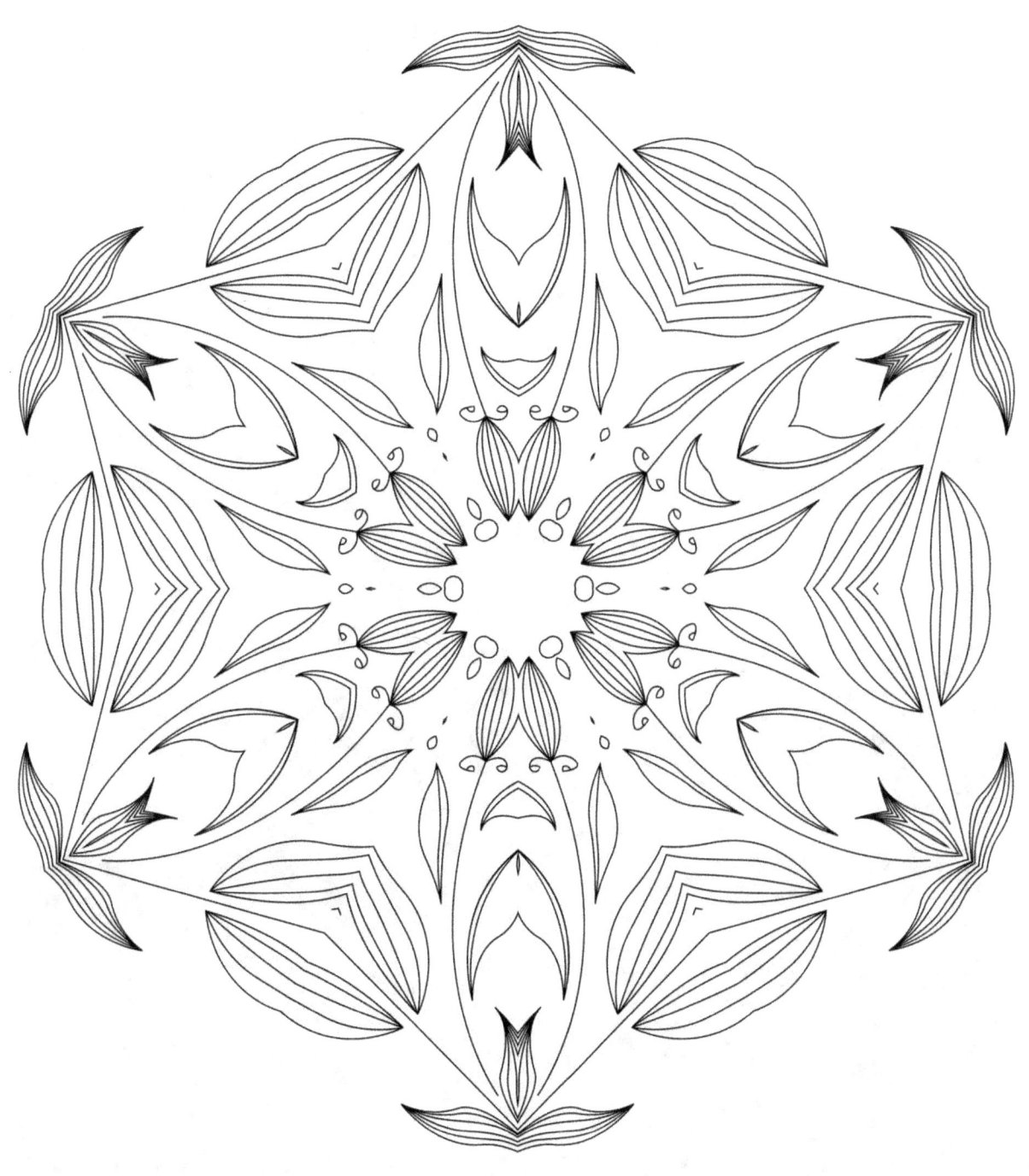

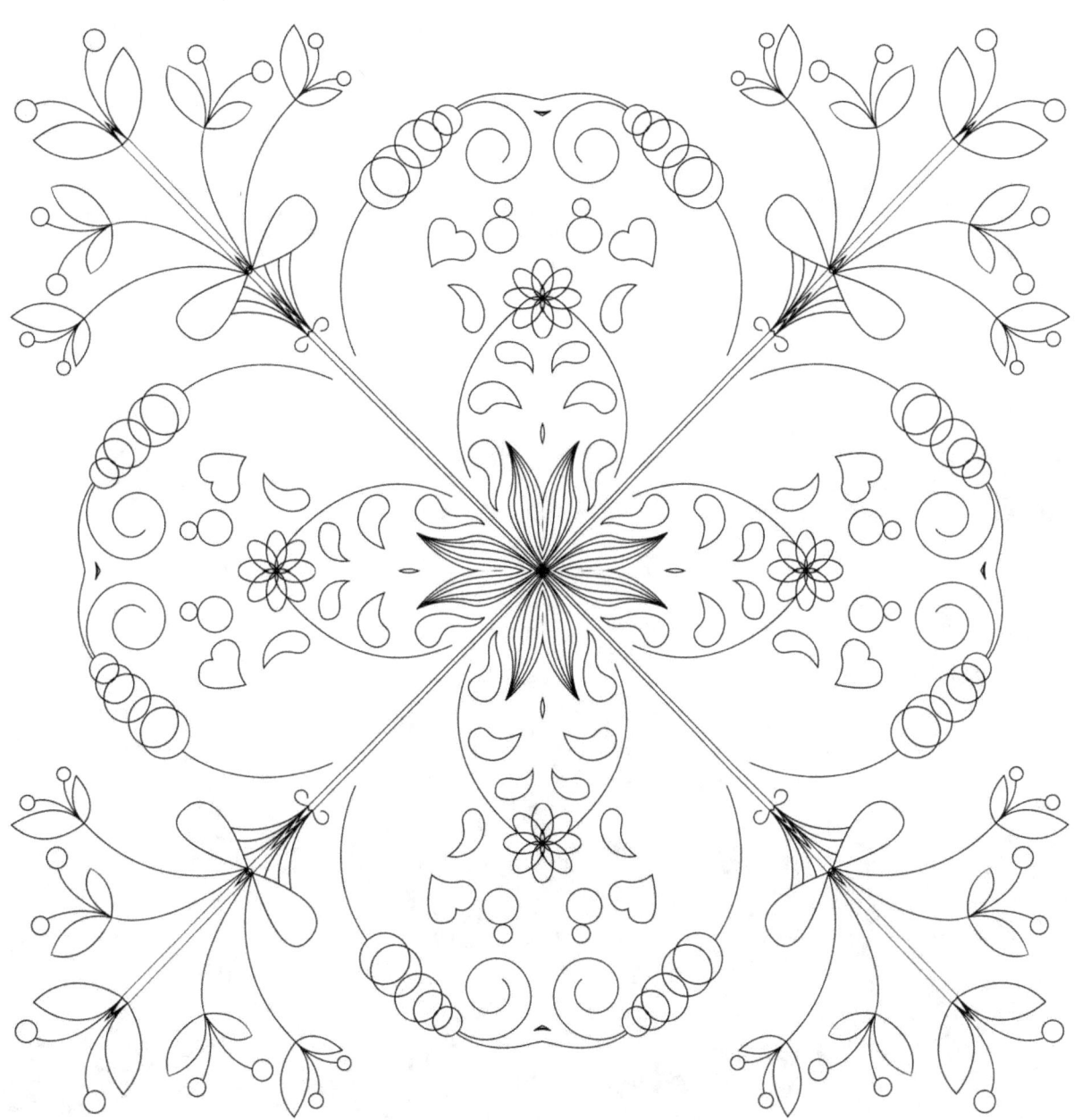

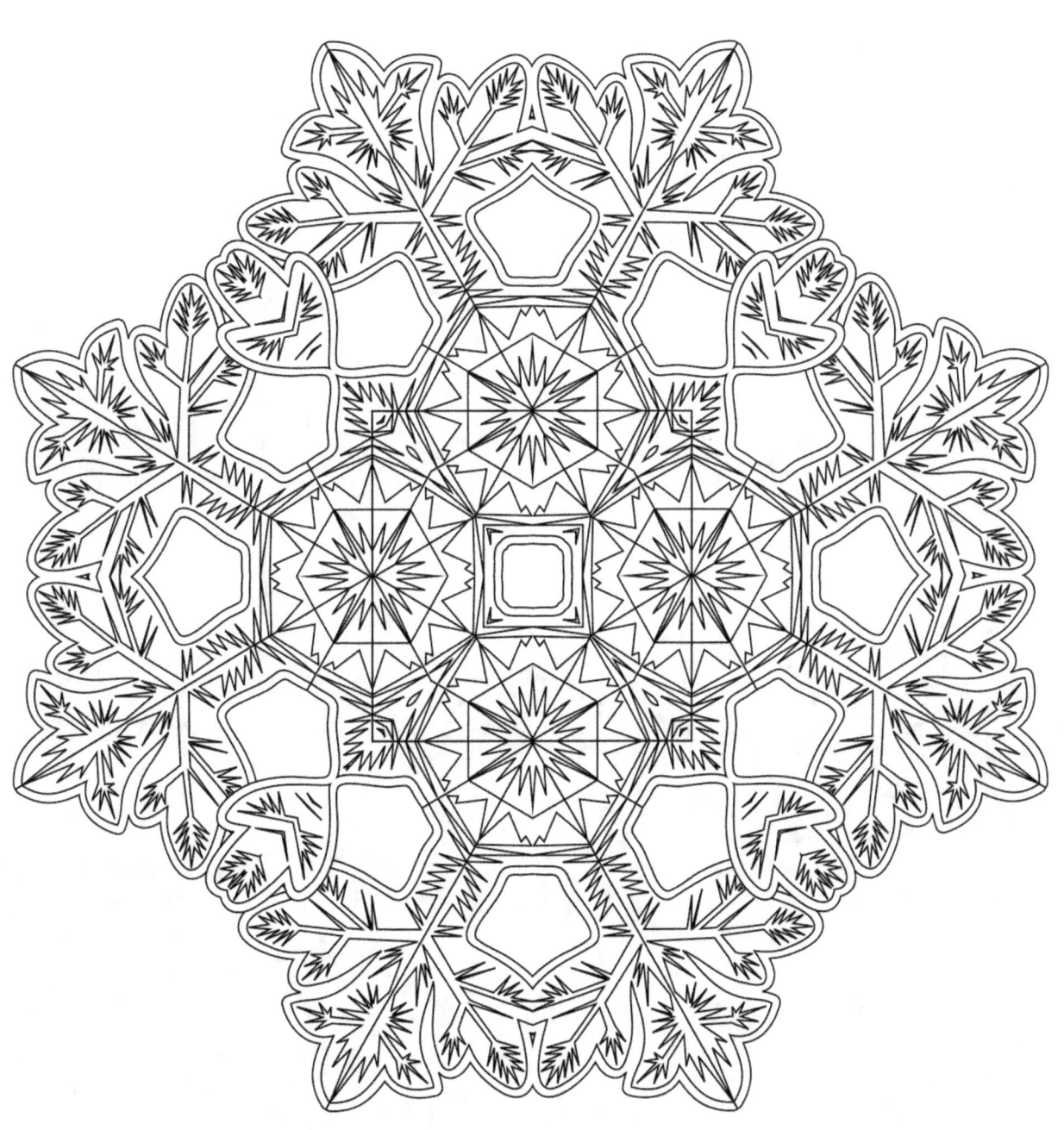

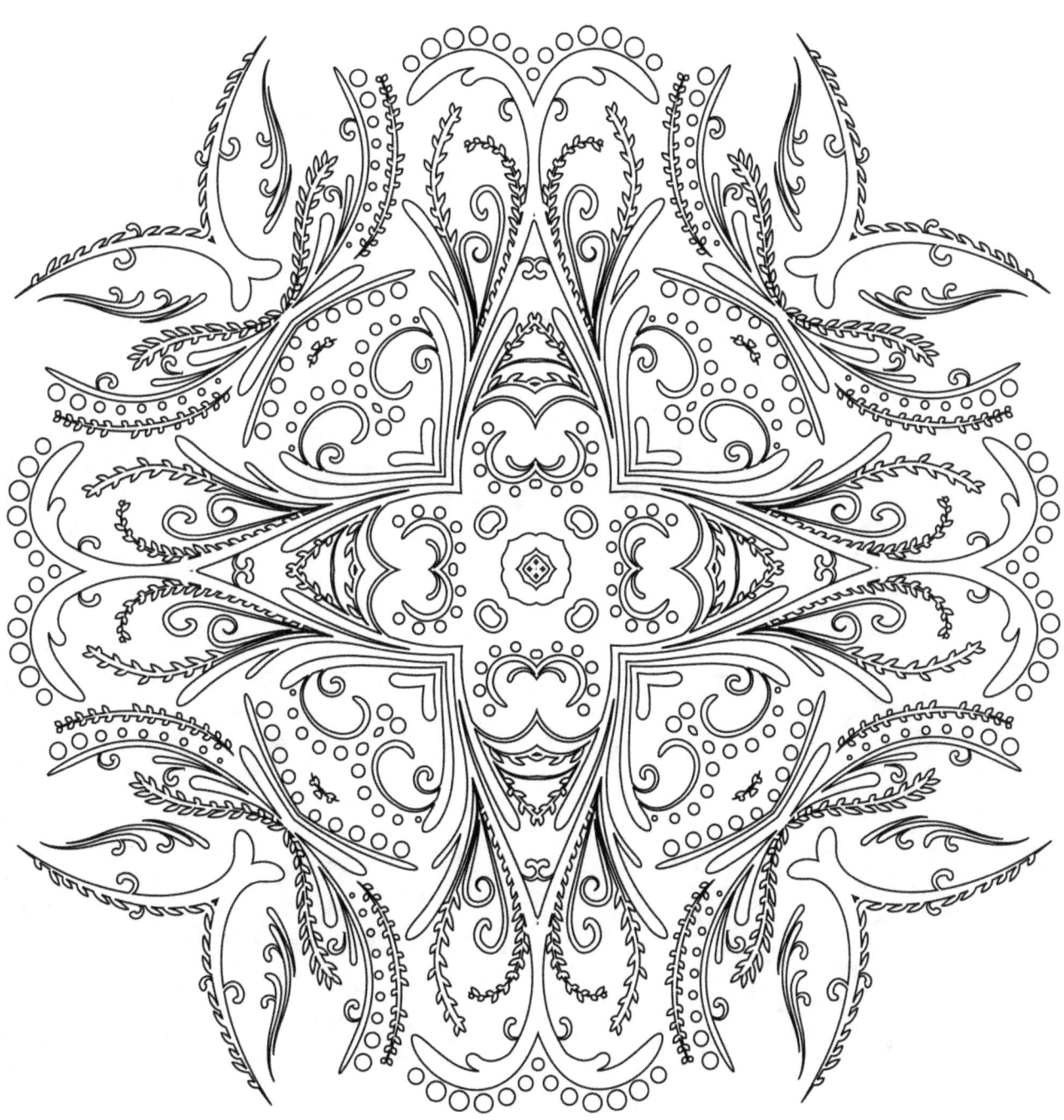

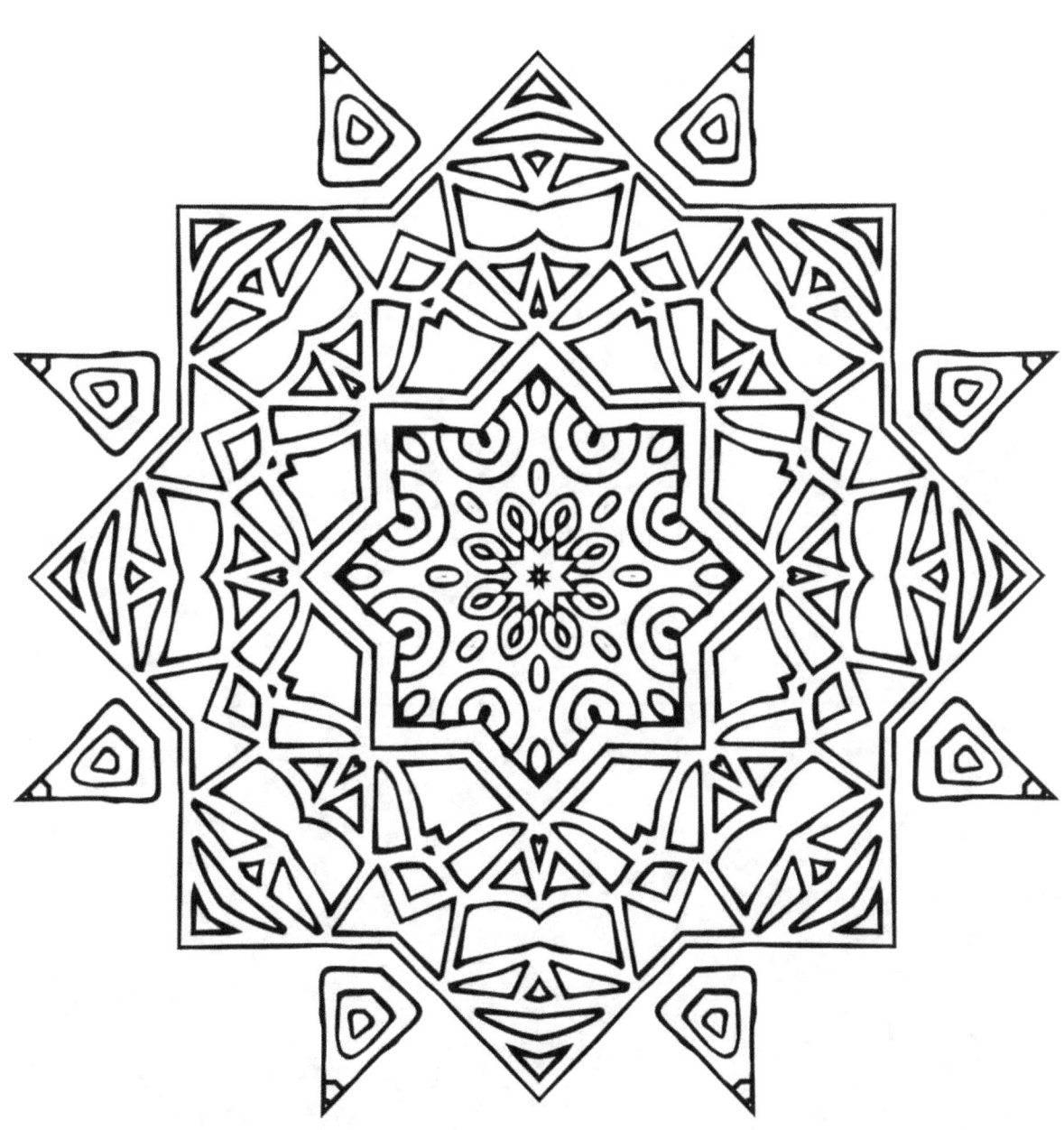

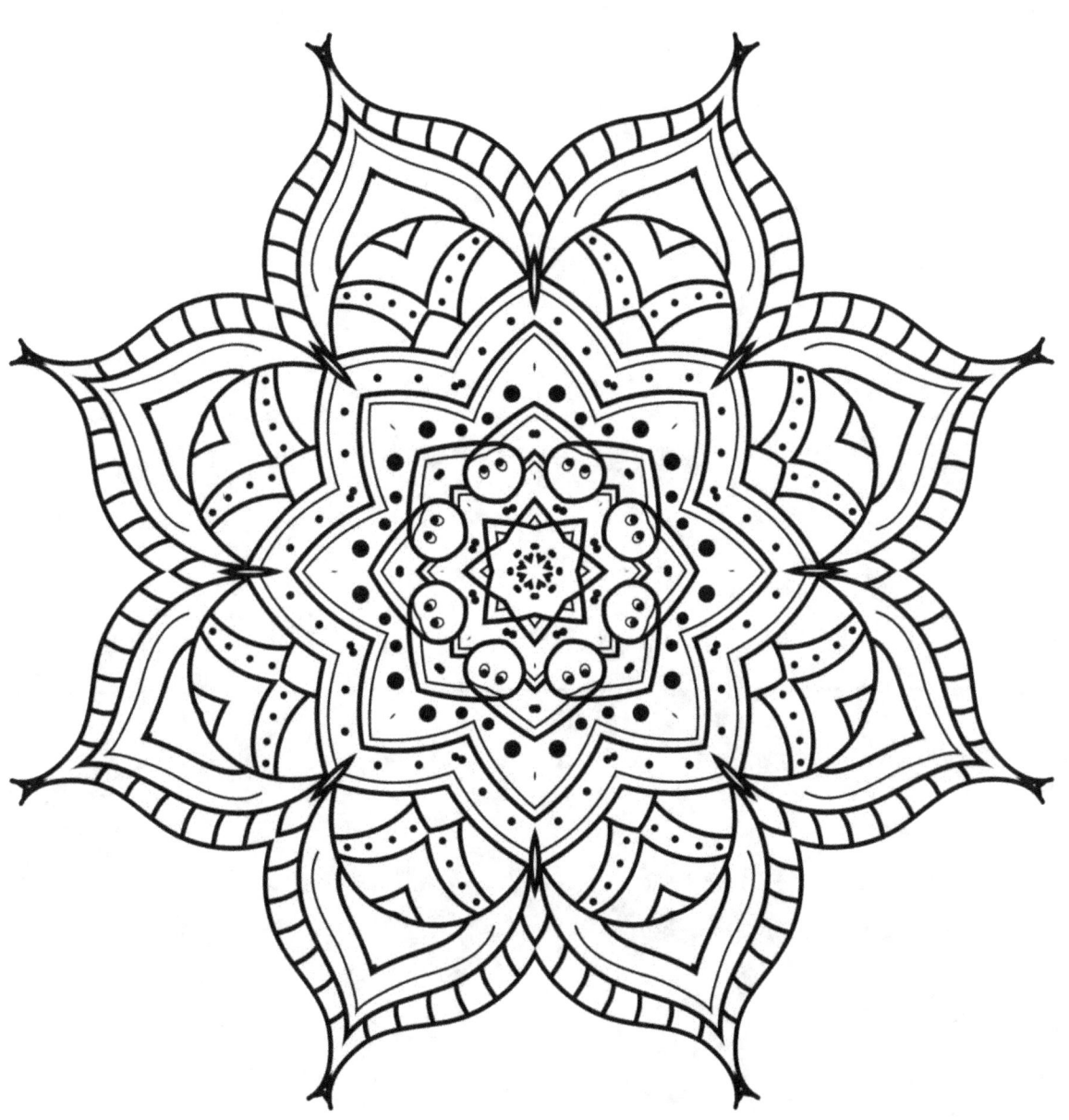

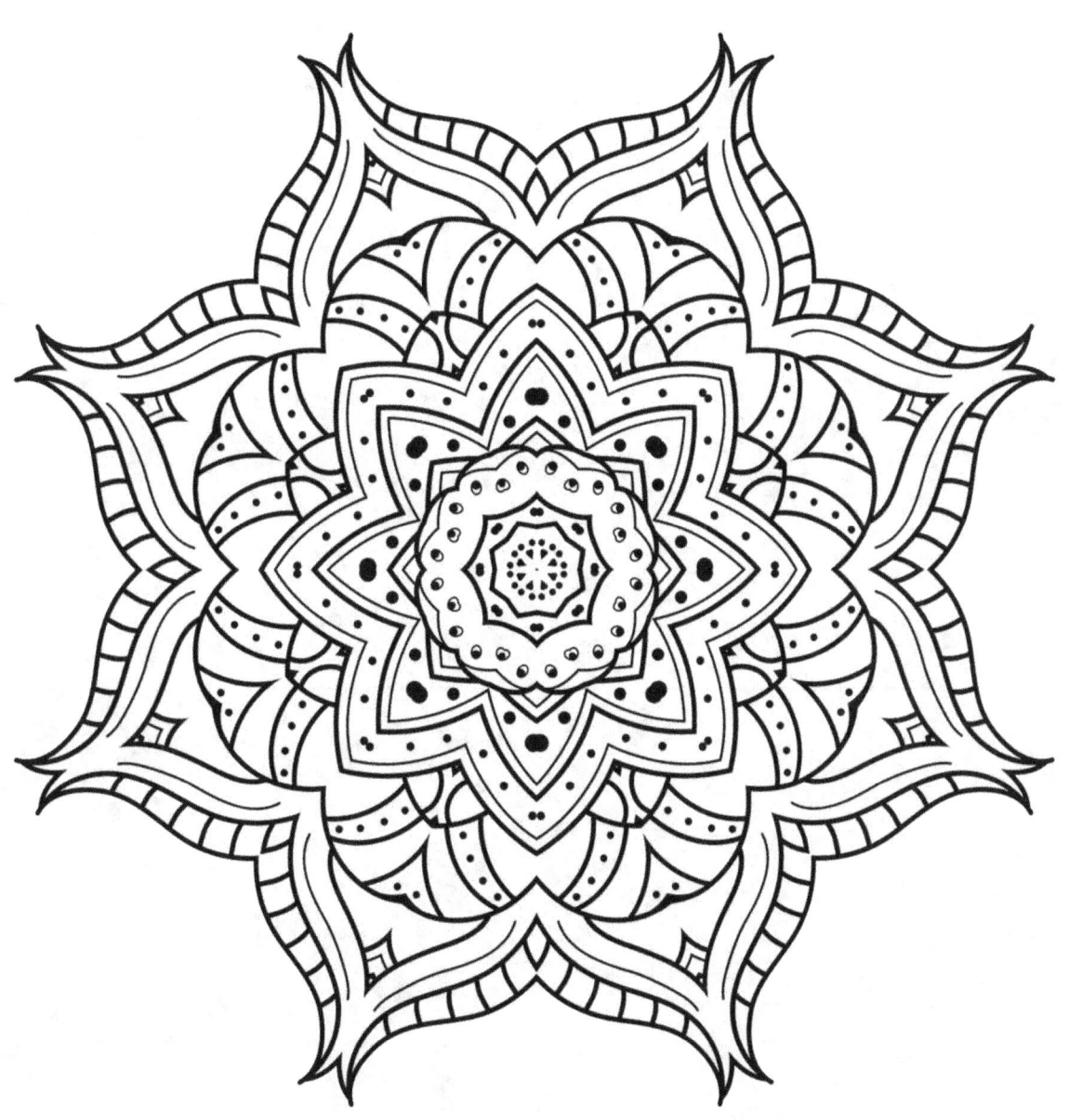

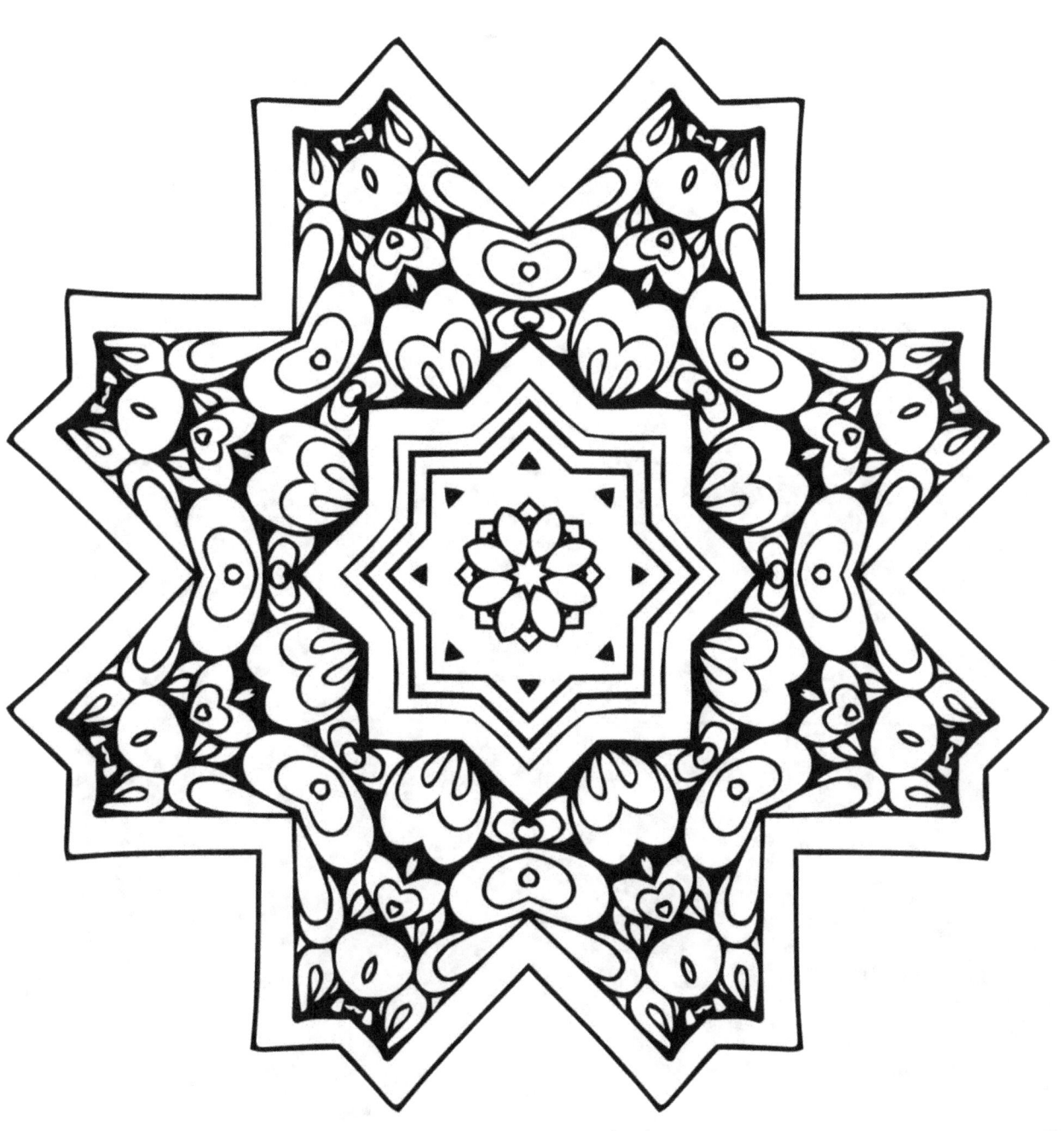

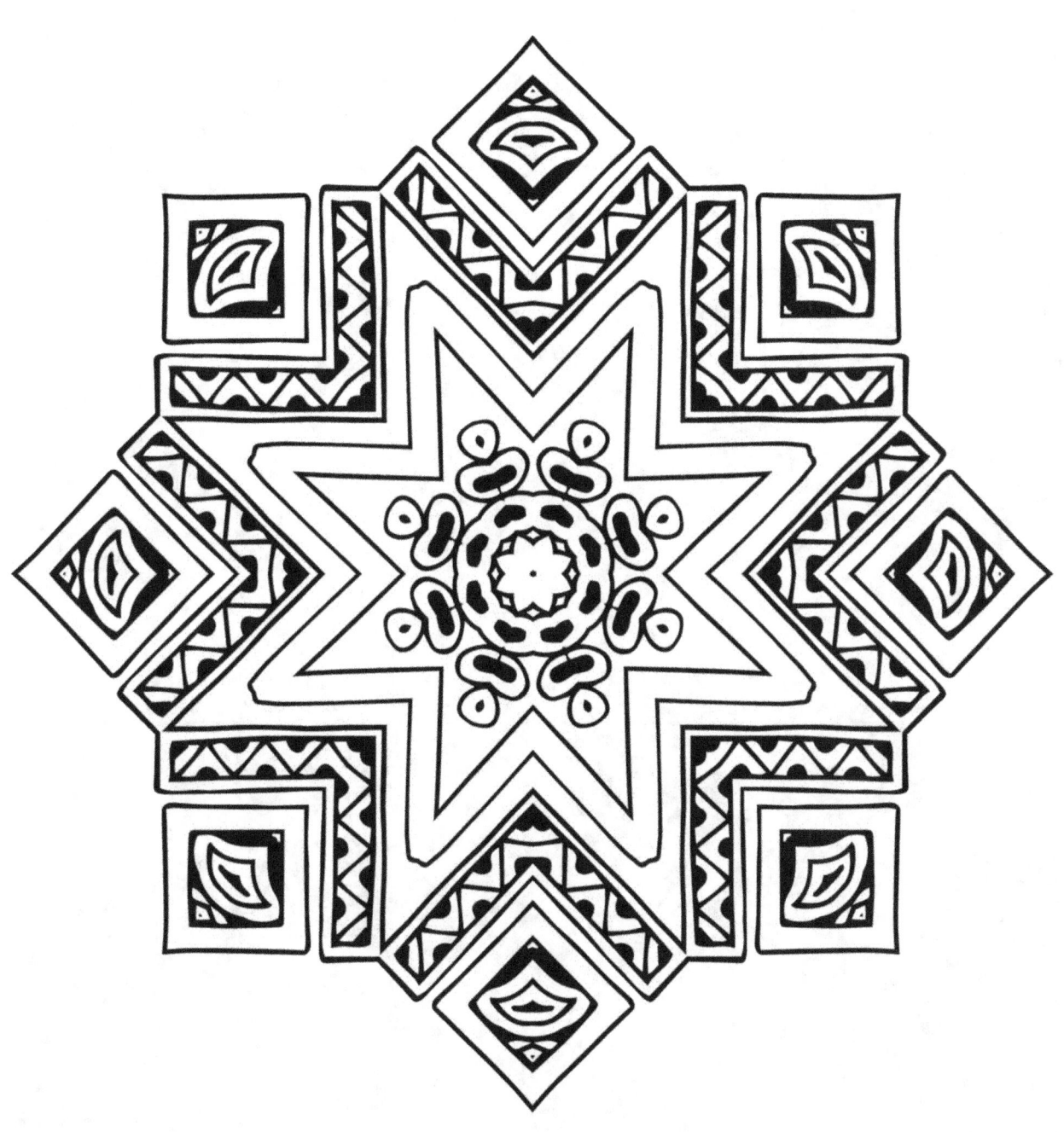

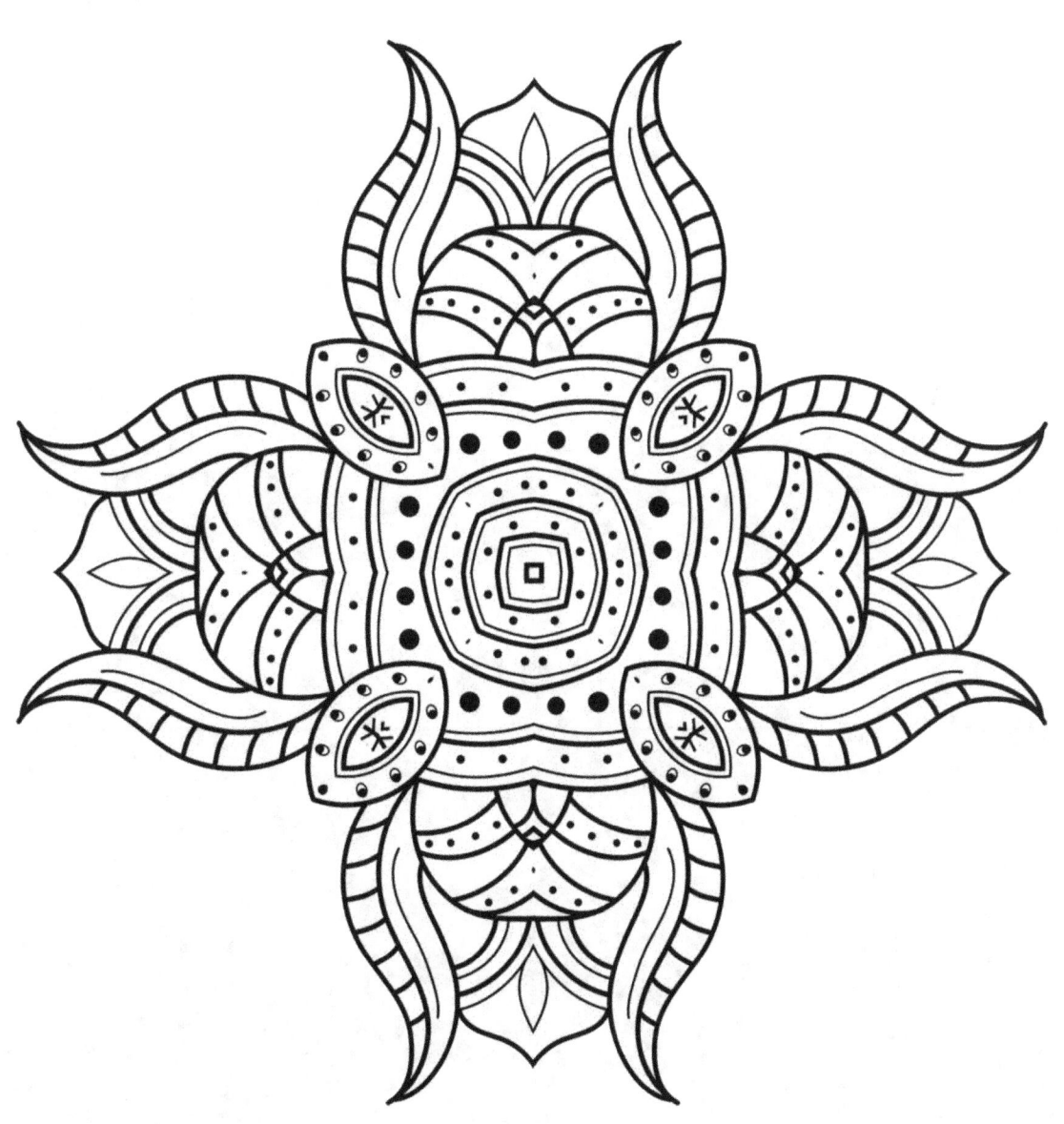

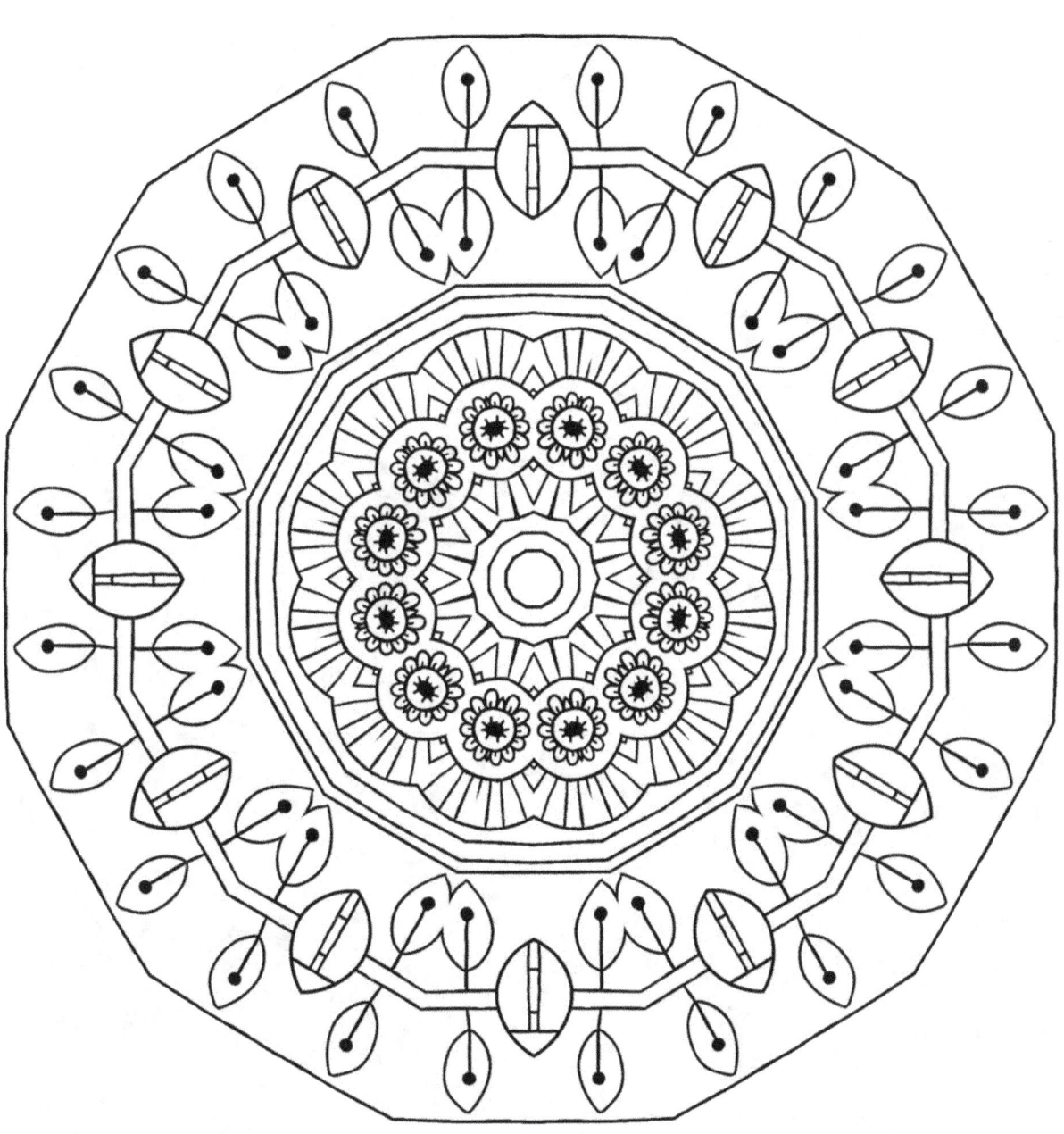

www.ingramcontent.com/pod-product-compliance
Lightning Source LLC
Chambersburg PA
CBHW081144180526

45170CB00006B/1930

9781541165175